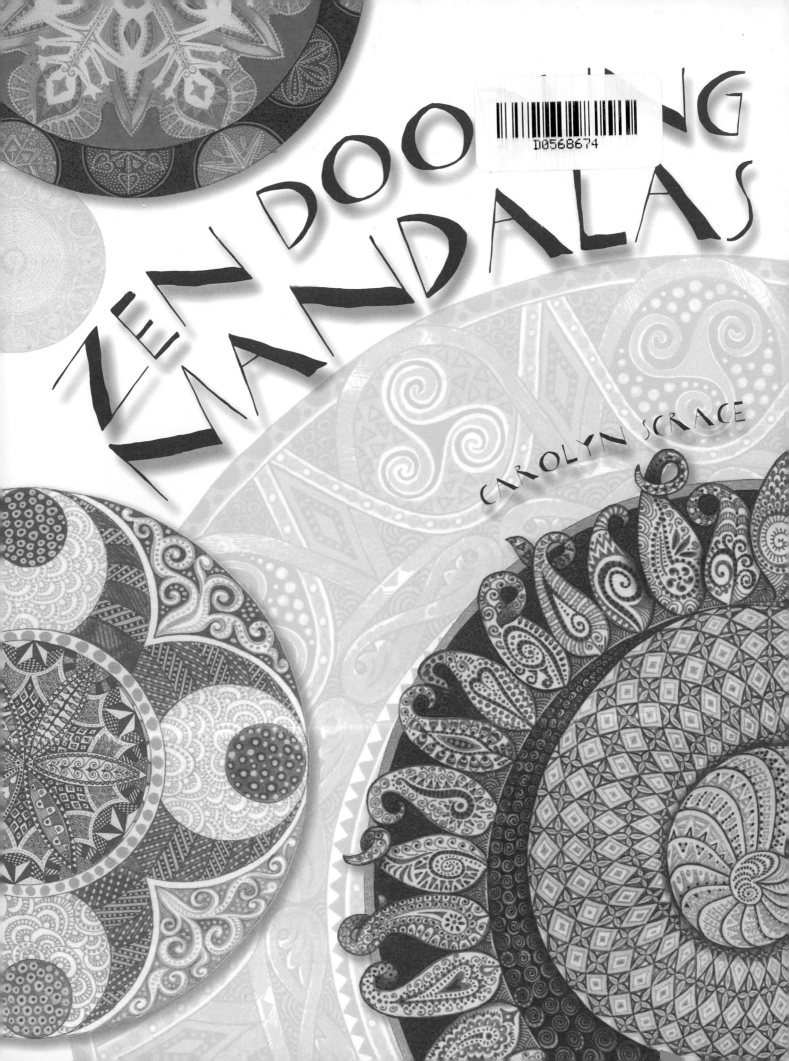

ZENDOO ING MANDALAS

CAROLYN SCRACE

First edition for North America, the Philippines, and Puerto Rico published in 2014 by Barron's Educational Series, Inc.

First Published in Great Britain in MMXIV by Book House, an imprint of The Salariya Book Company Ltd

© The Salariya Book Company Ltd MMXIV, 25 Marlborough Place, Brighton BN1 1UB

All inquiries should be addressed to:
Barron's Educational Series, Inc.
250 Wireless Boulevard
Hauppauge, New York 11788
www.barronseduc.com

ISBN: 978-1-4380-0468-6

Library of Congress Control No. 2014932880

9 8 7 6 5 4 3 2

Printed and bound in China

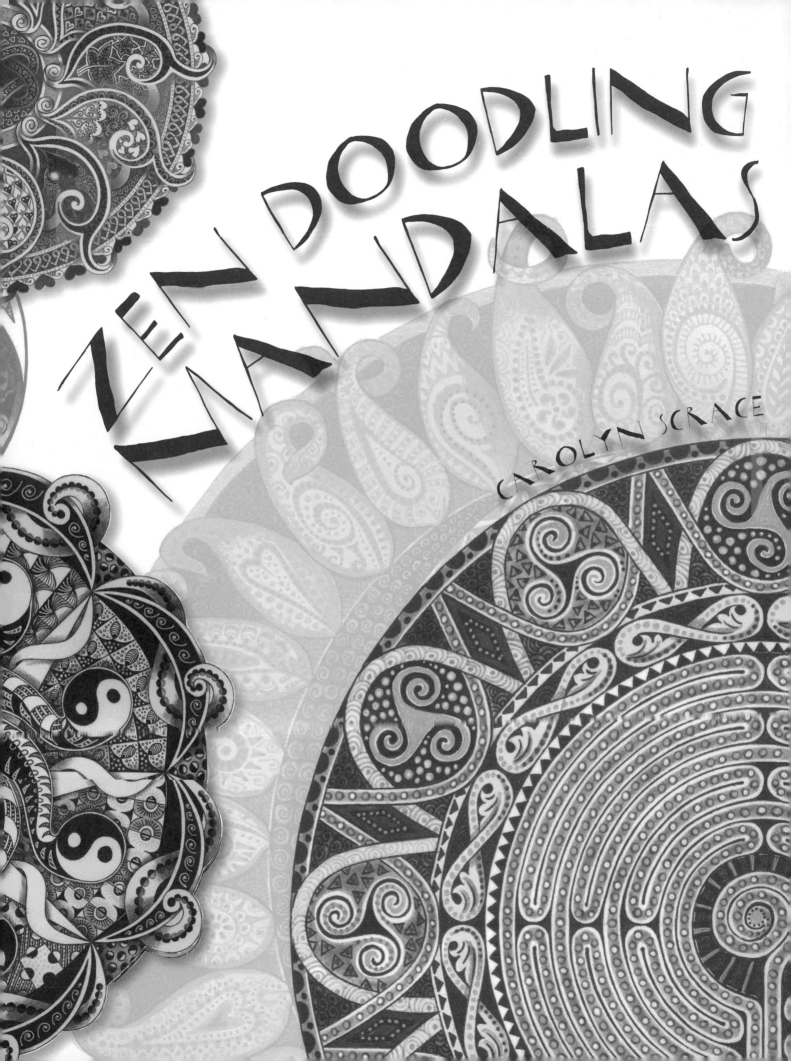

ZEN DOODLING MANDALAS

CAROLYN SCRACE

Contents

Introduction

*Z*en Doodling Mandalas is designed to enable you to get the maximum enjoyment and relaxation from Zen Doodling. This book is packed with inspirational mandalas and bold, exciting designs aimed to encourage creativity and build artistic confidence. Step-by-step instructions show how to achieve various simple techniques.

A fun activity

Zen Doodling is a really fun activity that anyone can enjoy doing. No special materials or equipment are needed; doodling can be done any time, anywhere. It is incredibly relaxing— simply let your mind wander and start Zen Doodling!

Unique designs

This book explores basic color theory and shading techniques. It explains how to create patterns and includes advice on using themes and designing unique, inspiring mandalas.

Self-discovery

Zen Doodling can become a journey of self-discovery. During prolonged periods of Zen Doodling the conscious mind will tend to drift and it's possible to achieve a heightened sense of self-awareness—of our relationship to others and our place within the universe.

> " The aim of art is to represent not the outward appearance of things, but their inward significance. "
>
> *Aristotle*

Mandalas and meditation

The word *mandala* comes from the Sanskrit language and means "sacred circle." Circles have been used as potent symbols by many cultures throughout history. In general, a circle symbolizes the cycle of life, wholeness, continuity, and harmony. Combining Zen Doodling with mandalas creates powerful images which can be used to aid meditation and help individuals focus inward.

Sand mandala

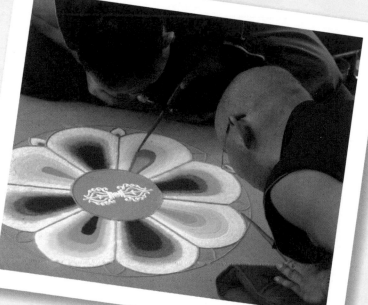

Mandalas date back to the 4th century when they were originally created for the Buddhist religion. They were often in the form of scrolls carried by travelers, thereby spreading their popularity. Buddhist monks famously construct exquisite mandalas out of millions of grains of colored sand. Shortly after completion, the monks destroy the mandala to symbolize the impermanence of existence. They then disperse the sand in a river in order to symbolically share its blessing.

8

Meditation

- Find a quiet spot that is neither too hot nor too cold.

- Make sure you can sit comfortably, and place your mandala at eye level in a well-lit position.

- Close your eyes. Breathe deeply, slowly, and evenly letting your whole body relax. Start to visualize the mandala; picture the center and try to focus your own energy inward to your heart. Keep still and breathe deeply until you are ready to open your eyes.

- Still breathing deeply, look at your mandala with your eyes slightly unfocused. Keep your gaze centered and try to see the entire image as a whole. Now start to explore the different parts of the mandala.

- Focus your eyes and begin to study the outer edges of the mandala, slowly working your way toward its center. Feel the power at the core of the design, close your eyes, and let the energy flow back and forth.

- If you feel tired at any point, stop the exercise, concentrate on your breathing and, when you are ready, slowly stand up.

- Try meditating for just two minutes. Gradually increase the time you devote to it - meditation works best if done on a daily basis.

Pens

Marker pens are ideal for filling in large areas of color. Fine **technical pens** are great for adding delicate patterns.

Watercolor paints

Watercolor paints come in liquid form, in solid blocks or in tubes. Dilute the paint and use it to create washes to cover large areas with color or to paint patterns.

Tools and materials

There are endless art materials that can be used for Zen Doodling. The basic tools are scraps of paper and a pencil. Use whatever you have at hand. The most important thing is to get started, have fun, and enjoy the experience!

Experiment!

Here are some suggestions of materials you may want to try, many of which have been used in this book. Experiment with different combinations and discover what works best for you.

Felt-tip pens

Felt-tip pens come in a wide variety of colors and line widths. They are ideal for blocking in areas of color.

Fineliner pens

Fineliner pens are ideal for coloring in intricate patterns. They come in a wide range of colors.

Watercolor paints

Notebook

For jotting down ideas for patterns and doodles!

Cartridge paper

Cartridge paper comes in different thicknesses (weights) and surfaces. Use thick cartridge paper for washes and smooth-textured paper for fine, detailed work. Some cartridge paper has a tendency to make felt-tip and fineliner pens bleed.

Gel pens

Metallic gel pens come in several colors including gold, silver, and bronze. Use them to add richness to areas of detail. **White gel pens** look most effective when used on dark colors.

Bristol board

Both sides of **Bristol board** (or Bristol paper) can be worked on. It comes in various thicknesses (2-ply, 3-ply, etc.) and textures. Smooth is best for detailed work.

Pencils

Pencils vary from hard to soft and make a wide range of shades from gray to black. **Pencil crayons** produce subtle shades. Use them to fill in blocks of color, layering different colors for added depth and richness.

Metallic gel pens

Pencil crayons

Pencils

11

Pattern building

tart by drawing a simple line. Add a short line, turn it into a triangle, add a dash, then a dot... Relax and enjoy the enriching experience of Zen Doodling!

The triangle shape that inspires this progressive doodle quickly turns into a diamond that is then embellished with stripes and curls.

From a diamond shape the pattern develops into a cube and then an elaborate heart shape. The possibilities are endless!

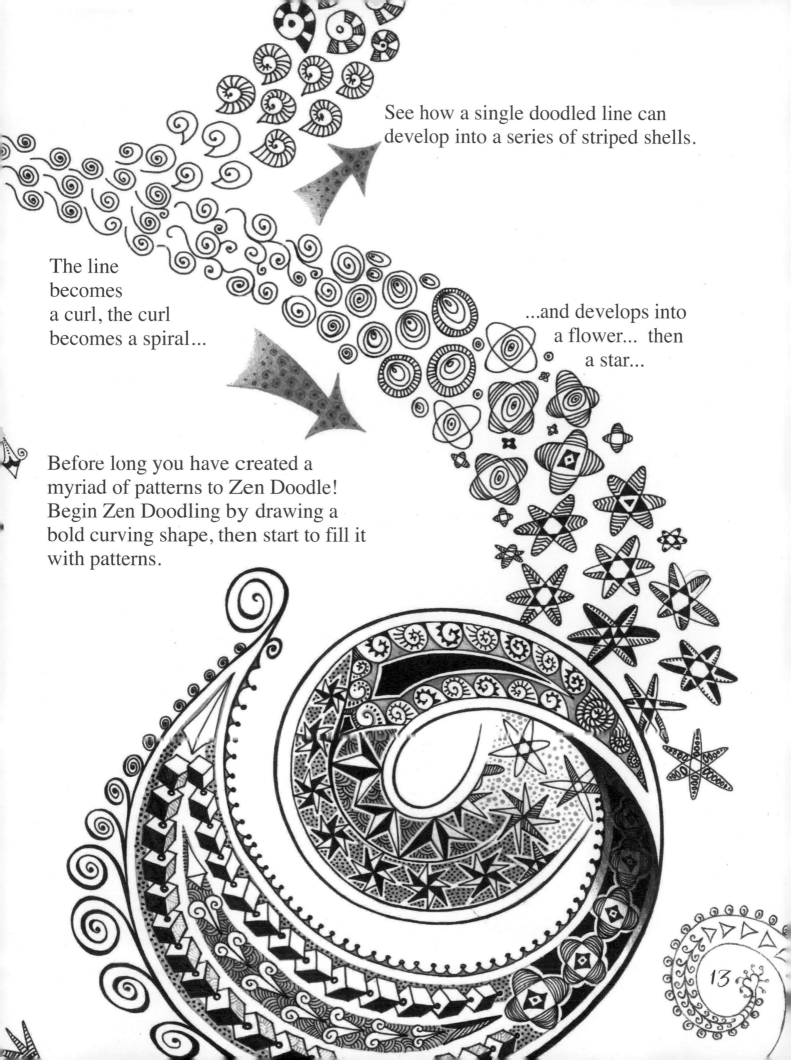

See how a single doodled line can develop into a series of striped shells.

The line becomes a curl, the curl becomes a spiral...

...and develops into a flower... then a star...

Before long you have created a myriad of patterns to Zen Doodle! Begin Zen Doodling by drawing a bold curving shape, then start to fill it with patterns.

Deconstructing

oodling complex patterns can appear daunting at first. However, by studying the basic shapes, you can break the design down into simple, easy-to-draw components.

Note: Yellow lines indicate the next step.

To create the pattern below:

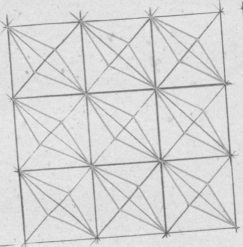

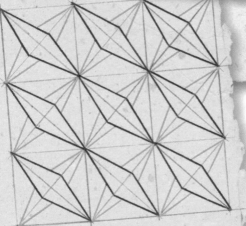

Draw a pencil grid. Add diagonal lines as shown.

Draw in diamond shapes on one set of diagonal lines using a fineliner pen.

Add diamond shapes on the opposing diagonal lines.

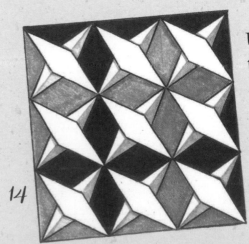

Use gel and felt-tip pens to color in the design (left). Create dramatic results by using a range of tones from gray to black. Try another color scheme and add some simple doodles (right).

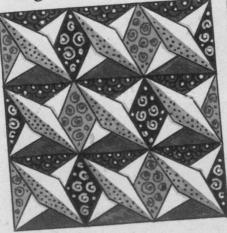

For this jigsaw-shaped pattern:

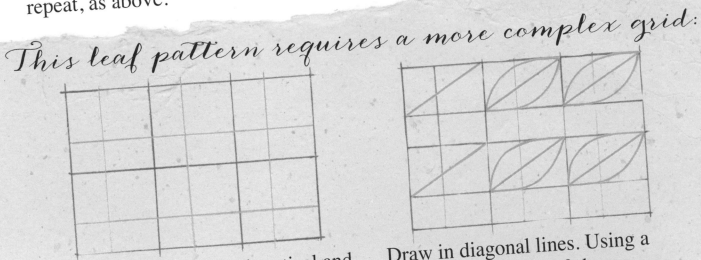

Draw a pencil grid. Then draw in a wavy line and repeat, as above.

Add more wavy lines in the opposite direction. Draw in circles.

Color in alternate shapes using black and white gel pens and felt-tips.

This leaf pattern requires a more complex grid:

Draw a pencil grid. Add vertical and horizontal lines.

Draw in diagonal lines. Using a fineliner pen, add leaf shapes.

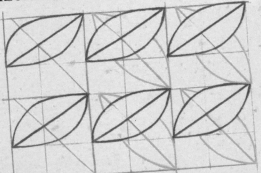

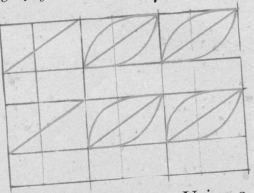

Draw in more diagonals (as shown). Using a fineliner pen, add bigger leaf shapes behind the first set.

Color in the pattern. Use line work and flat color to create interest.

Color Theory

Primary colors

Yellow, red, and blue are the three primary colors and are the only hues that cannot be mixed from any other colors. All other colours derive from a mixture of these primaries.

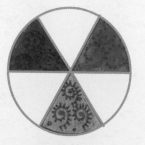

Secondary colors

Orange, green, and purple are the three secondary colors. They are created by combining any two of the primary colors. (Mixing blue and red creates purple, for example.)

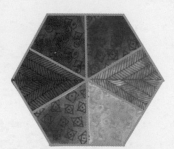

Tertiary colors

There are six tertiary colors; yellow-orange, red-orange, red-purple, blue-purple, blue-green, and yellow-green. They are created by combining a primary and its nearest secondary color (see large diagram opposite).

Complementary opposite colors

Complementary opposite colors lie opposite on the diagram (e.g., red and green, yellow and purple). Used together, they produce vibrant, clashing color schemes.

Analogous colors

Analogous colors lie next to each other on the color diagram (e.g., purple, purple-red, and red). As they share a color (in this case red), they produce harmonious color combinations.

The color wheel shows the following labels arranged around it:

Red-purple · Red-orange · Blue-purple · Yellow-orange · PURPLE · ORANGE · GREEN · Blue-green · Yellow-green

Color temperatures

Red, orange, and yellow are warm colors; they reflect strong passions ranging from love to anger, or emotions such as happiness, enthusiasm, and energy.

Green, blue, and purple are cool colors; they reflect peace and tranquillity. Cool colors are comforting and nurturing.

17

Light and shade

Building up layers of tone to create the effect of light and shade adds depth to Zen Doodles. Practice different shading techniques such as hatching, cross-hatching, and scribble.

Hatching

Start with short, evenly spaced lines. Gradually space the lines closer and closer together. The density of the lines creates the variation in tone.

Scribble

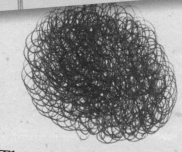

The density of the scribbled line creates tonal variation.

Cross-hatching

Start with an area of hatching. Add more layers of hatching, changing the line direction each time. (This is easier to do if you keep turning the paper around.)

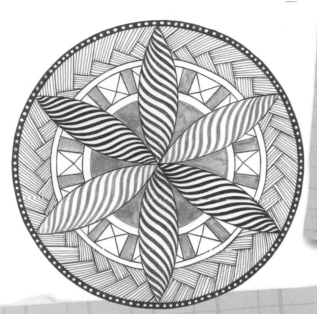

Added shading makes these yellow shapes appear rounded.

The cross-hatching on this pattern makes the boxes look solid.

This mandala design looks flat and dull, whereas the shaded version (below) has depth and vibrancy.

Decide on a constant light source before you start to add shading.

Light source

Graduated shading makes the plaited border look 3D.

By adding shading on and around the leaf shapes, they appear to be rounded and raised above the rest of the pattern.

In the mood

lind doodling or "taking a line for a walk" is a terrific way of getting in the mood for Zen Doodling and releasing your creative flow. All you need is a large sheet of paper and a marker or felt-tip pen. Put your pen on the paper, close your eyes and...

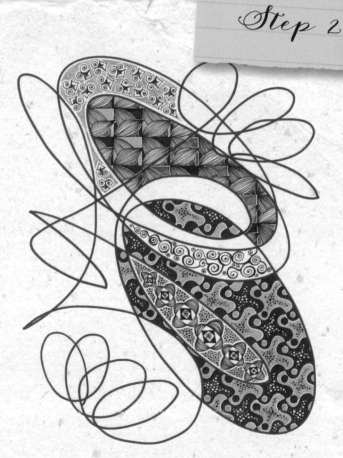

With your eyes closed, draw a continuous, looping, curvy line without lifting your hand off the paper.

Using some of the random shapes you have created, feel yourself unwind as you start Zen Doodling into them.

20

Try using a limited palette of colors to start with. The analogous color scheme below is mixed with black and gray to produce very effective results.

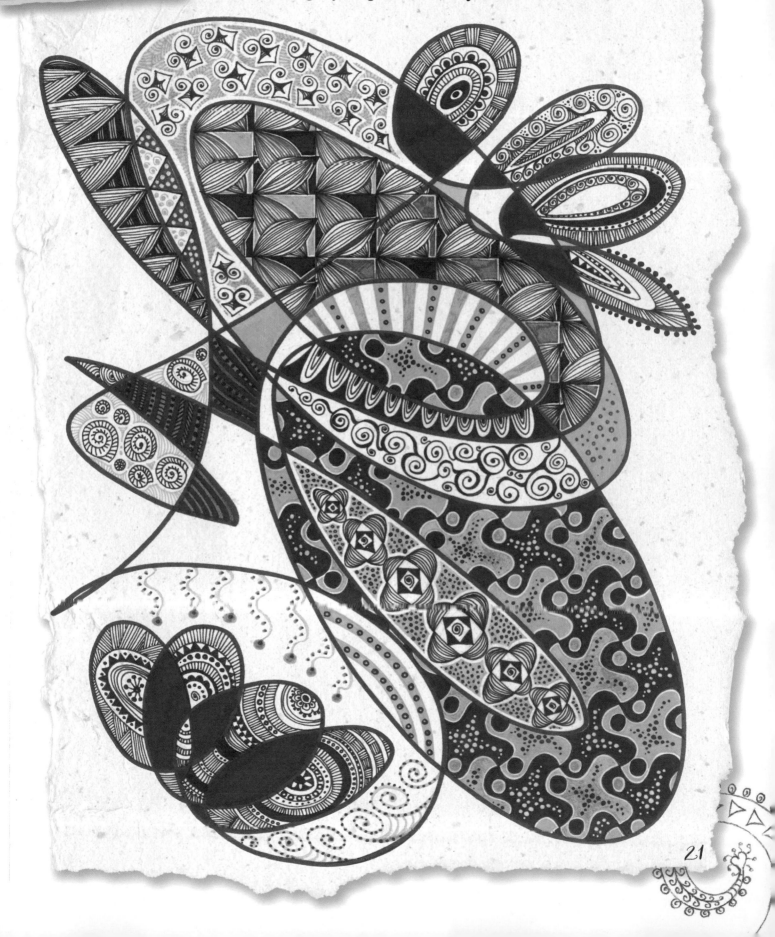

Inspiration

The world around us is full of beautiful patterns ideal for Zen Doodling! Carry a small sketchbook with you to jot down ideas on the go. Use it like a scrapbook and stick in magazine clippings, photographs—anything that inspires you!

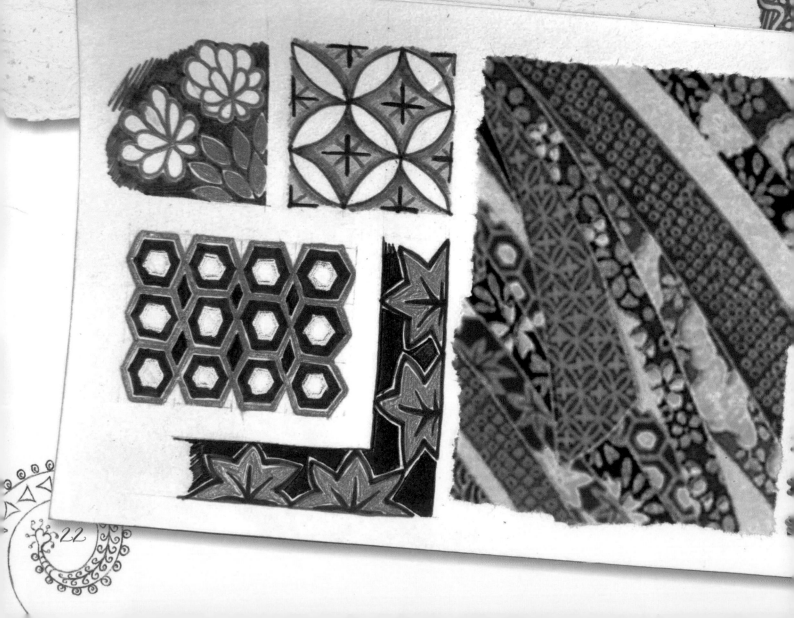

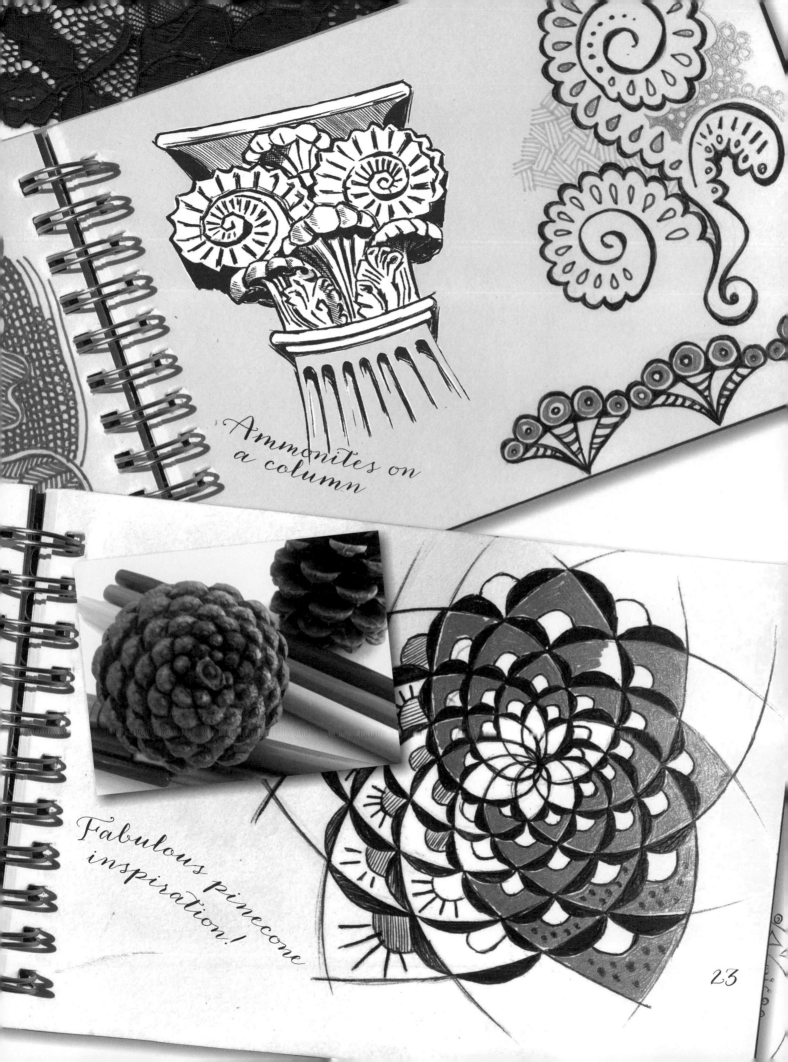

Ammonites on
a column

Fabulous pinecone
inspiration!

23

Getting started

The quickest way to draw a mandala is to take a selection of plates, cups, coins or anything round and smooth that you can use as a template to draw around.

Hold a plate or saucer firmly down on your paper, then trace around it in pencil. Use a ruler (or any straight-edge such as a pen or pencil) to draw in a vertical and a horizontal guideline through the center.

Now draw in smaller circles by tracing around a cup or glass as shown. Draw the first circle in the center, then add a circle to the top, bottom, and either side. Use the straight lines as guides.

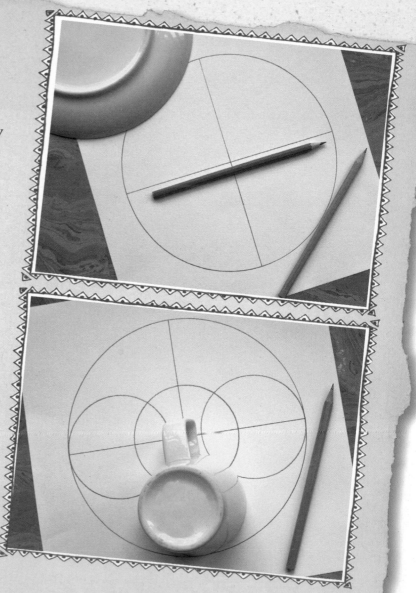

Add more circles by tracing around the base of the cup or glass and some other different-sized circular objects. Keep your design simple at this stage.

Start Zen Doodling!

Go over the design with a black ballpoint or fineliner pen, then erase any pencil lines. Now that the design work is done it's time to relax—choose your colors and immerse yourself in Zen Doodling!

Different angles

ther methods of constructing a mandala use a protractor or compass to create complex designs. These tools are easy to use and will enhance your artistic skills. Experiment by working on small, simple mandalas to start with, to build your confidence.

Using a protractor

A protractor enables you to divide your mandala circle into any number of equal sections.

A circle is made up of 360°, so if, for example, you want 9 sections, divide 360° by 9 = 40°. Use the protractor to mark out increments of 40° (80, 120, 160°, etc.).

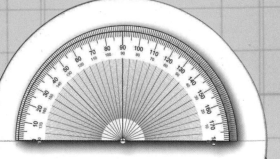

First draw a circle. Put in a horizontal line through the center. Place the protractor on the line and align it with the center.

Mark out the size of each section in degrees. Then use a ruler to draw lines from the center to each marker.

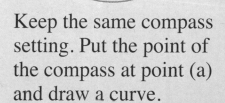

To create complex geometric mandalas it may be better to use a compass.

Start by drawing a circle.

Keep the same compass setting. Put the point of the compass at point (a) and draw a curve.

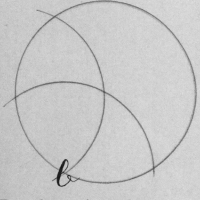

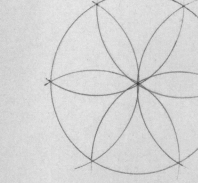

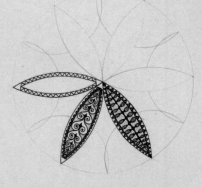

Put the point of the compass at point (b) and draw a second curve.

Continue moving around the circle drawing curved lines.

Add small semicircles around the circumference. Start Zen Doodling into your mandala.

Asymmetrical cat

Traditionally a mandala has a symmetrical design that radiates out from a central point. Asymmetric mandalas are now becoming increasingly popular. They still evolve from a central point which reflects our own inner core. The act of drawing a mandala releases creative energies and helps an artist to relate and connect with everything in the universe.

Focus

The cat in the center of this design is the focus of the mandala, while the other cat shapes radiate outward. The asymmetry of the design is due to the central cat's pose, and in particular its tail, which curls down out of the picture. The coloring of the four smaller cats also creates imbalance.

> The cat went here and there
> And the moon spun round like a top,
> And the nearest kin of the moon,
> The creeping cat, looked up.
>
> *William Butler Yeats*

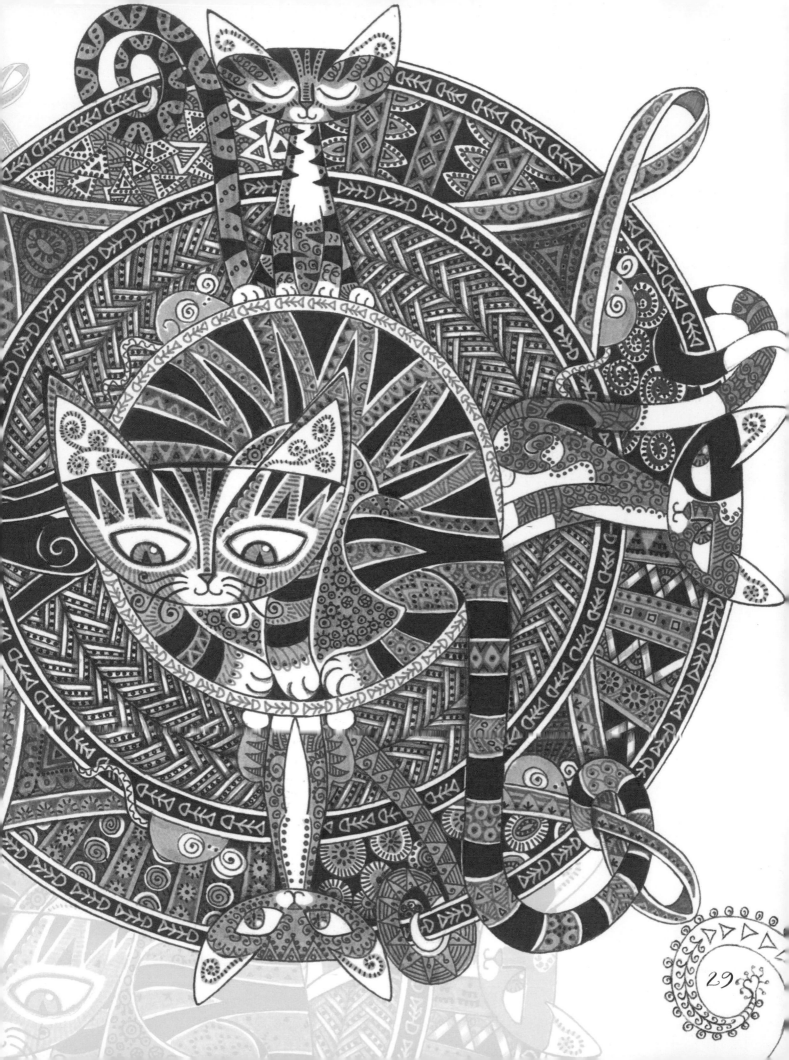

29

How to draw a cat

This book is designed to enable you to get maximum enjoyment and relaxation from your Zen Doodles. The step-by-step guide shows how easy it is to draw a cat by sketching a series of simple geometric shapes.

Simple shapes

Start by drawing a semicircle for the cat's head. Add a curved triangle for its body (1). Draw in two large ears and the cat's face (2). Exaggerate the size of the ears and eyes to make them stand out when you start Zen Doodling the drawing.

Step 3

Different poses

Draw in curved lines for the front legs and circles for the back paws (3). Add an enormous curly tail (4).

Adapt Step 2 to draw a side view of a cat (below). Add curved lines for the cat's body. Draw in the front and back legs as shown and add the curly tail.

Step 4

31

How to draw a cat from circles

A curled-up cat represents perfect tranquility. Use this image as the focal point and inner core for a mandala design. Adapt the cat's pose to fit the shape of a circle. Aim to draw your idea of a cat, rather than a realistic one.

Step 1

Start with two circles

Step 2

Ears

Freehand

Start by drawing two circles (1). Use cups, glasses, or whatever is at hand as a template, or draw the circles freehand. Sketch in a curved semicircle for the cat's head; add large, pointed ears (2).

Paws

Curves

Add curved lines for the front and back legs (3). Draw in two large eyes and the cat's nose and mouth. Finish off with a long, curling tail (4).

Step 4

Eyes and nose

Curving tail

Planning with a pencil rough

Carry a notepad with you at all times for scribbling and doodling any ideas that come to you. The pencil planning stage can be the most exciting part of your design! Use scrap paper so you never feel that it's too good to mess up. Make lots of thumbnail sketches of your ideas and designs.

Thumbnail sketches

Symmetrical cat?

Asymmetrical cat!

Fishbone pattern

Asymmetrical mandala

...add mice?

Different types of cat

Experiment

When you are happy with your thumbnail sketch you may want to draw a slightly more detailed version. Experiment with tonal values and try contrasting areas of black and white. Think about the colors you might use. A limited palette often works best.

Wish list

Cats, mice, fish pattern, herringbone, fishbones, different types of cats: stripy, ginger, patchwork. Cat's cradle wool patterns? Curvy patterns – Art Nouveau...

Structure

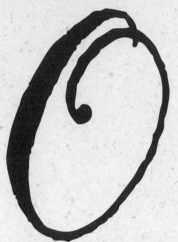

Once you have mastered drawing the main elements of your mandala, start sketching out your finished design. Think about how a cat watches a mouse and draw in the cats' eyes following different mice in the picture. Have fun with the cats' tails by varying the way they curve and wrap around the picture frame.

Handy Hint

Use a pencil and compass to draw a series of circles. Take a ruler and draw a vertical and a horizontal guideline through the center point. Now add two more guidelines midway between them. These lines will help you to position the cats. Add a decorative curl between each cat.

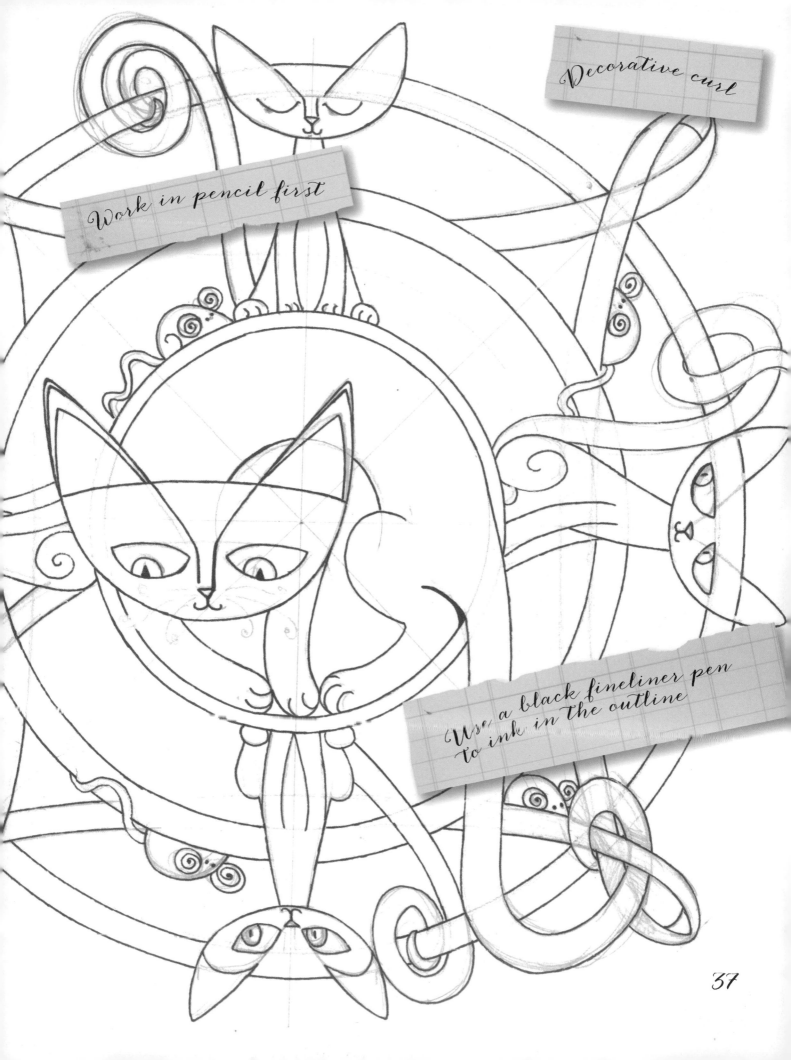

Decorative curl

Work in pencil first

Use a black fineliner pen to ink in the outline

37

Doodle the cat

The simple act of stroking a cat is known to reduce physical and emotional stress. Cats naturally exude calming, positive energy, which makes them the ideal subject for a mandala. If you own a cat, draw in anything that you identify with it: favorite foods, toys, the pattern of its coat. Try to think like a cat as you Zen Doodle into your design.

Patterns

Now the fun really begins. Relax and start to Zen Doodle. Begin by blocking in some of the black areas using a marker pen. Add pale brown felt-tip to the cat's markings, using fineliner pens for detailed work. A herringbone pattern makes an apt choice for doodling the central border.

Herringbone

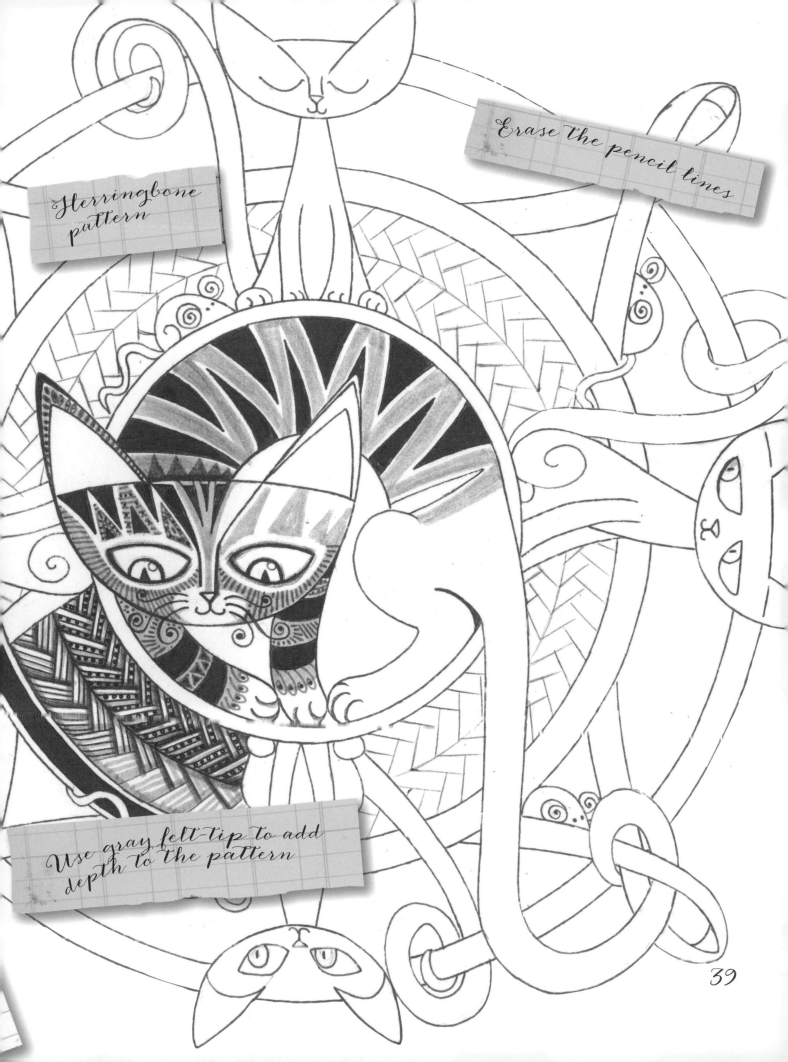

Herringbone pattern

Erase the pencil lines

Use gray felt-tip to add depth to the pattern

39

Making patterns

Have some scrap paper handy for trying out patterns and color schemes before you start doodling the finished mandala. Keep all your experimental scraps—they will prove invaluable for future doodles.

Black felt-tip with white or silver gel pen fishbones

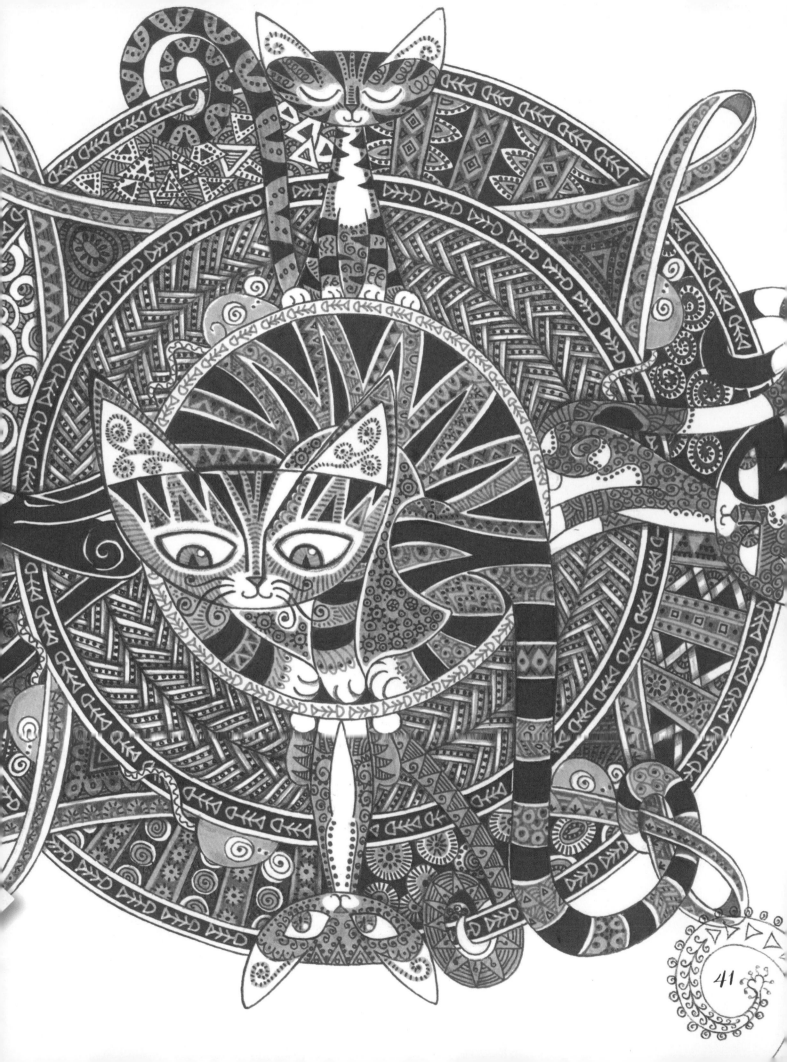

41

Sun and moon

Each day the sun rises in glorious splendor. It traverses the sky, creating warmth and light, before finally setting in a blaze of color. The moon, on the other hand, is mysterious and cyclic. It waxes and wanes and disappears, only to be reborn again. As you create your Zen Doodle mandala, compare the contrasting characteristics of the sun and moon; warm, nurturing brightness and joy as opposed to a cool, secretive darkness.

Symmetry

This design is symmetrical: the main components are balanced around both the horizontal and vertical axes. The sun is the focal point of the mandala, with the eight faces of the moon drawing attention in toward the central feature.

"Everyone is a moon, and has a dark side which he never shows to anybody."

Mark Twain

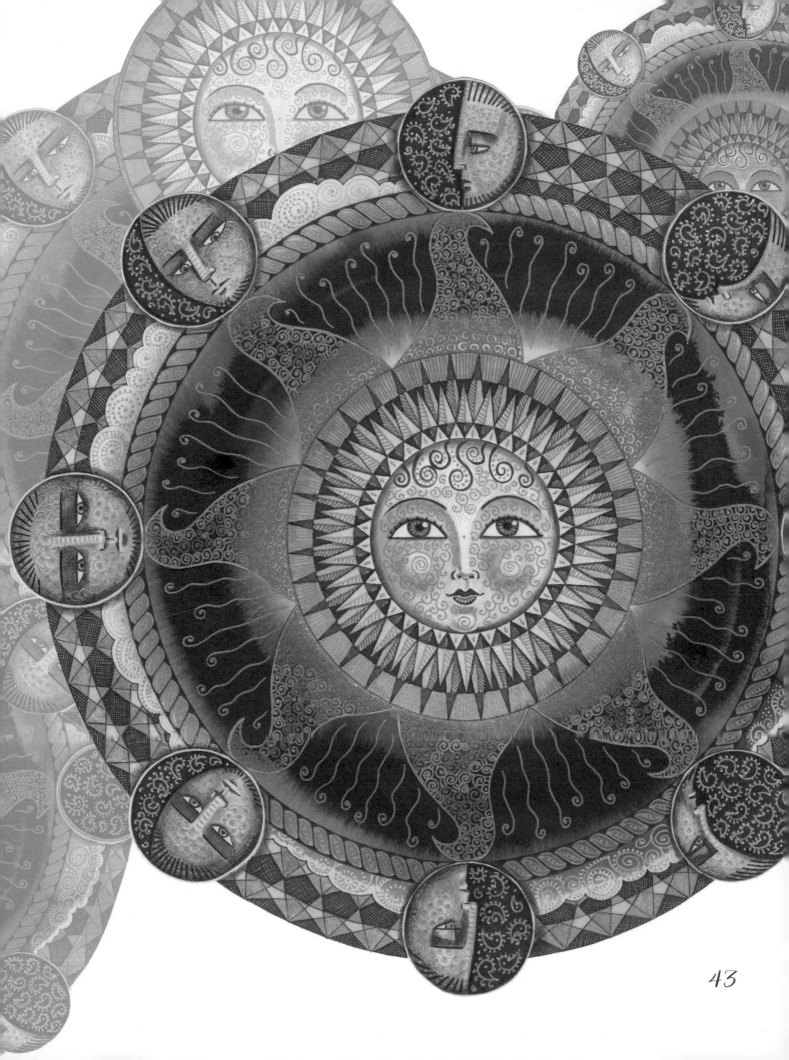

43

Lunar cycles

While high and low tides are a direct result of the moon's gravitational pull, many people believe that certain phases of the moon also affect the mind and body. Full-moon days are thought to have the most powerful effects on both passions and emotions.

Rough sketch

Think which elements you wish to include in your mandala, and roughly sketch in your idea. This design has the sun in the middle, surrounded by the eight phases of the moon.

44

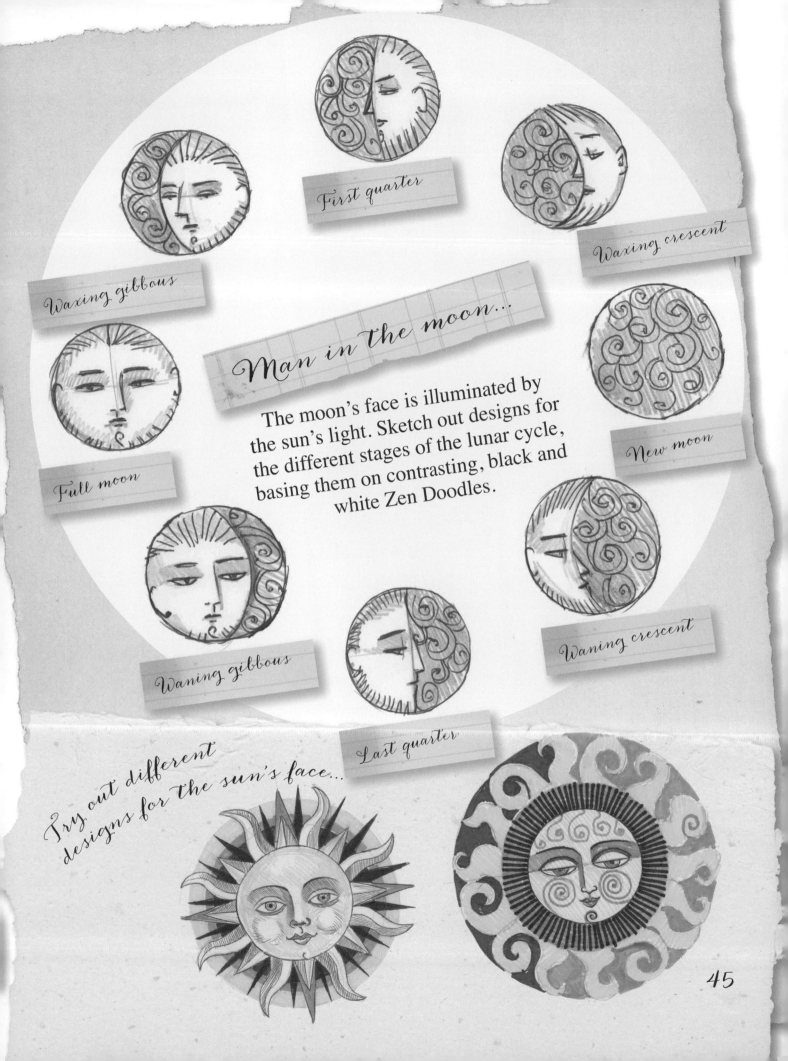

First quarter

Waxing crescent

Waxing gibbous

Man in the moon...

The moon's face is illuminated by the sun's light. Sketch out designs for the different stages of the lunar cycle, basing them on contrasting, black and white Zen Doodles.

New moon

Full moon

Waning crescent

Waning gibbous

Last quarter

Try out different designs for the sun's face...

Watercolor wash

A watercolor wash is one of the most exciting and liberating backgrounds to Zen Doodle. The colors run and bleed at random, creating fantastic shapes and tonal variations. Let the unpredictable nature of watercolor washes inspire your patterns. "Go with the flow" as you doodle the mandala.

Happy accidents

Watercolor washes often produce unexpected results. However, it is still worth making a color rough of your intended design even though the final mandala may be slightly different.

Draw a circle for the sun and a larger one for the border. Wet the paper using a large brush loaded with water (leave the center dry). Paint a swirling circle of blue, then another of black onto the wet paper. Leave the colors to run together. Let the paper dry.

46

Color rough

These pale shapes make perfect clouds

Gold, gel pen doodles let the wash show through

The wash will add richness and depth to your colors. Experiment by doodling with gold, silver, and white gel pens. Bold patterns in black and white will stand out well against the dramatic tones of the watercolor.

Contrast

The greater the contrast between light and dark areas in a painting, the greater the impact. Use tonal contrast to make the sun into a dramatic center of interest in this mandala.

Watercolor wash

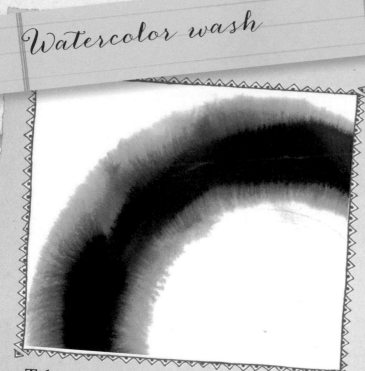

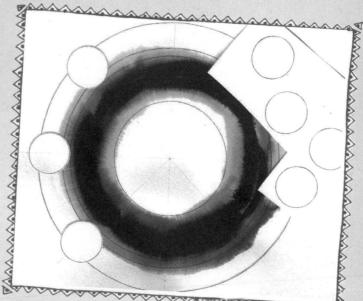

Take a sheet of thick watercolor paper. Following the instructions on page 46, paint a circular watercolor wash the size of your mandala. Leave to dry completely.

Draw circles for the outer border and a circle for the sun at the center. Measure out eight 45° sections with a protractor. Cut out eight small circles of watercolor paper and stick these in the center of each border section.

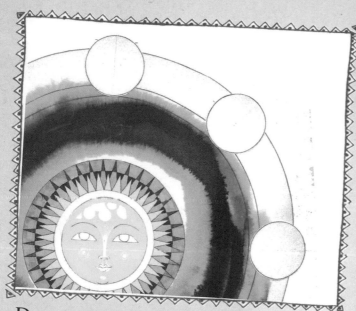

Draw one circle for the sun's face and two more for its rays. Use a protractor to mark out 5° increments. Draw the sun design and start blocking in the main areas of color.

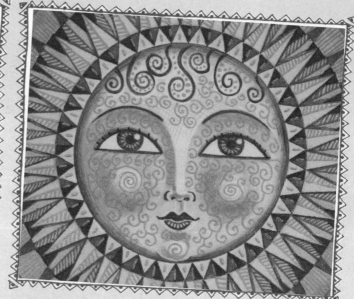

Use any colored pens—ballpoints, crayons, or fineliners—to add hatching to the face. Finish drawing the features, then adorn with gold gel pen doodles.

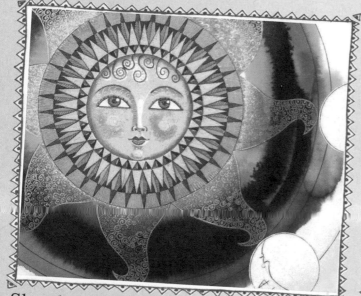

Sketch in big, curving sun rays stretching out toward each moon. Fill them with delicate, lacelike Zen Doodles. Try using a combination of gold and bronze-colored gel pens.

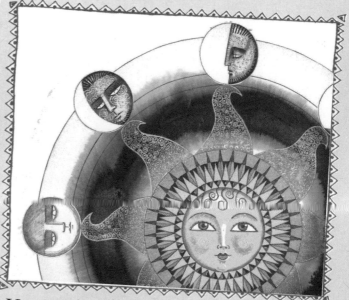

Use hot colors to reflect the sun's warmth. By contrast, the moon is cool and mysterious. Capture the moon's ice-cold, magical light by using blue-grays, silver, and a touch of gold.

Designing borders

Borders provide structure, separate areas of your design from one another, and also act as a frame for your mandala. Creating a circular border design requires some advance planning in the form of sketches and roughs.

Rope border

This makes a simple but effective border

Use a pencil to draw the circular border. Draw in slanting parallel lines at 45°. Color in with blue felt-tip pen. Experiment by using black and blue fineliner pens and white and gold gel pens to doodle your patterns.

Break it down

Star pattern

Construction lines...

...draw zigzags...

...add one line...

...and another!

Try out different color schemes and doodles.

Star-pattern border

Pencil in a star pattern around the outer border of the mandala. Go over the star shapes with a black ballpoint pen. Erase the pencil guidelines, then use fineliner pens to Zen Doodle the pattern.

Finishing touch

reate a magical night sky on which to mount your mandala. Contemplate the vast immensity of the universe as you Zen Doodle a myriad of stars and faraway galaxies.

Swirling nebulae

Carefully cut out your mandala and use double-sided tape to mount it onto a larger sheet of dark blue or black paper. Leave a narrow border around the outer edge of the mandala and start to Zen Doodle clusters of stars and swirling nebulae using gold, bronze, and white gel pens.

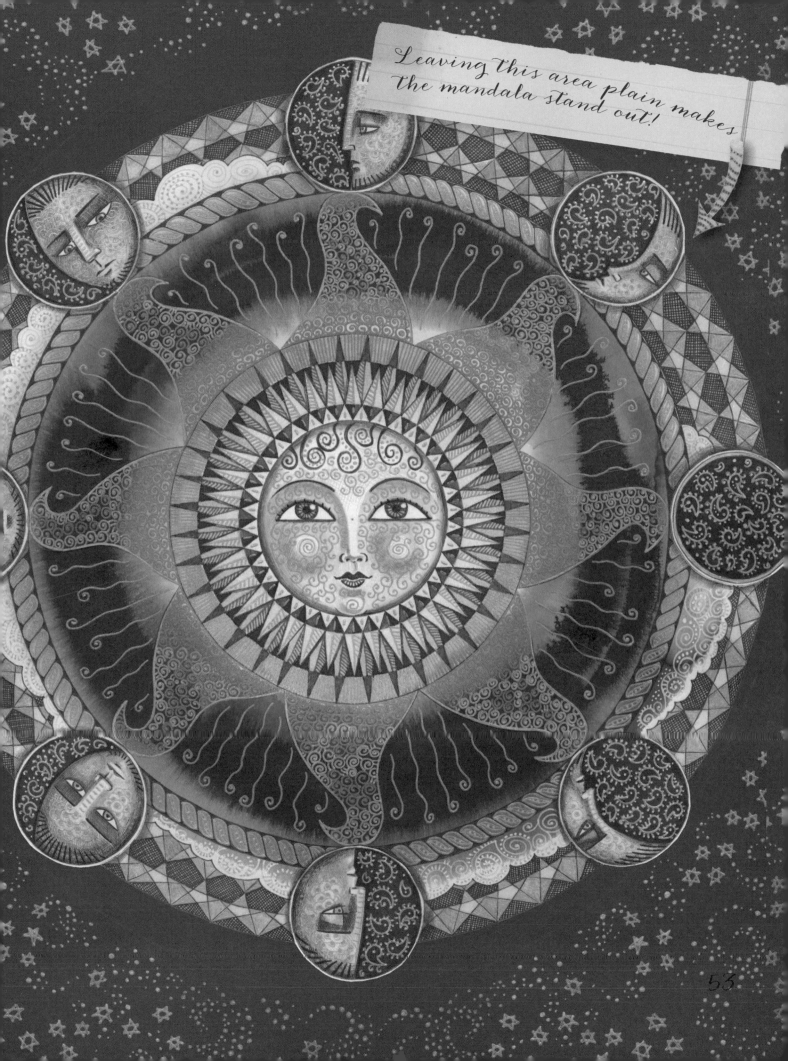

Leaving this area plain makes the mandala stand out!

53

Labyrinth

A labyrinth is a single winding path that leads from a starting point to the center. Labyrinth patterns are ancient, having universal and multicultural significance. All labyrinths have different levels of symbolic meaning. Use the pattern of a labyrinth as an integral part of a mandala design to symbolize your own spiritual journey by Zen Doodling the path through the sacred circle to the center within.

Reflections on Walking in the Maze at Hampton Court

« What is this mighty labyrinth - the earth,
But a wild maze the moment of our birth? »

British Magazine 1747

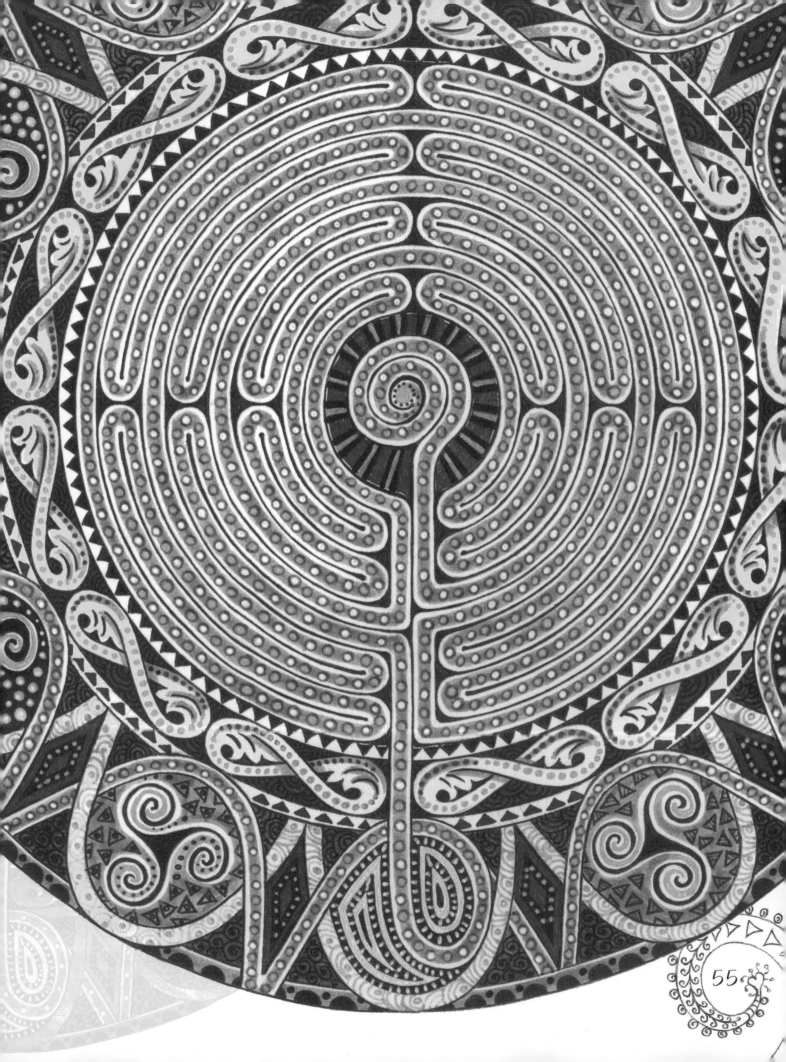

Ancient designs

Early examples of labyrinthine symbols date back to Neolithic and Bronze Age carvings. The same design was used on ancient coins from the island of Crete, where the name *labyrinth* originated. It was a recurring theme during the Roman Empire, often used in floor mosaics as a protective and decorative symbol. During the medieval period, the symbol evolved into a more complex design. The labyrinth has become increasingly popular for its historic interest and spirituality.

Classical labyrinth

Chakravyuha labyrinth

Classical labyrinths date back 4,000 years. This design has seven circuits or paths leading to the center. The cross which lies at the heart of the design becomes the focus of the artist's thoughts and energy.

The name Chakravyuha refers to a battle formation and dates back hundreds of years in classical Indian literature.

Medieval labyrinth

Medieval Cathedral labyrinths represented the path of the soul through life. Pilgrims followed the route of the labyrinth as an act of faith.

Labyrinth on the floor of Chartres Cathedral

Triple-spiral labyrinth

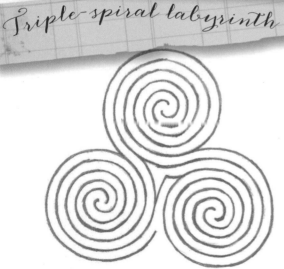

The triple-spiral design has been found in pre-Columbian America and Bronze Age Europe. It is commonly used as a symbol of female power, growth, and transition.

Medieval labyrinth

During the medieval period, the center of the labyrinth was believed to symbolize God and the entrance represented birth. The winding journey through the labyrinth stood for the laborious pathway to God.

57

Limited palette

Gold is a color that reflects the positive energy of the sun. It illuminates and enhances, imbuing richness and warmth into everything associated with it. Take gold as the central theme for your color scheme. For added impact use a limited palette of colors.

Rough sketch

Start by doing a small, rough sketch of the labyrinth in Chartres Cathedral. Add two bigger circles around it for borders. Extend the path into the labyrinth so it connects with the outer border and develops into a series of semicircles around its circumference.

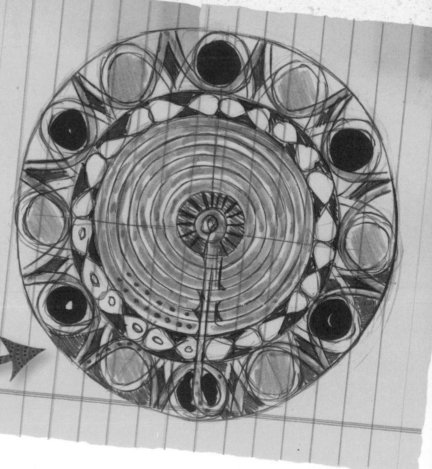

Triple spiral

This pattern is Celtic in origin. The three spirals all come from a center point and the design is said to symbolize the cycle of life: birth, death, and rebirth.

Infinity

Turn the figure 8 on its side and it becomes the symbol of infinity. Use it to create the pattern on the narrower border.

Step-by-step

Break down the pattern of the labyrinth into easy-to-draw stages. What at first glance appears complicated is in fact very simple to draw.

Easy-to-draw stages

Use a pencil and compass to draw a large circle. Draw a smaller inner circle. Add horizontal and vertical lines. Draw ten more equidistant circles, using a ruler to mark out the spaces between.

Next use a ruler to draw in vertical lines as above. Keep careful count of the number of circles the lines pass through or miss.

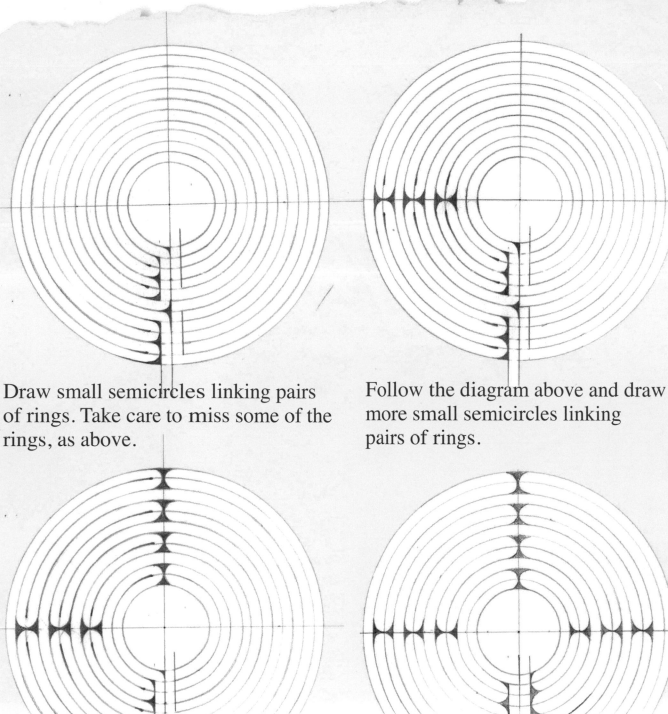

Draw small semicircles linking pairs of rings. Take care to miss some of the rings, as above.

Follow the diagram above and draw more small semicircles linking pairs of rings.

Continue working around the design, using the diagram above as reference and drawing more small semicircles linking pairs of rings.

Finish drawing the semicircles. Use your finger to trace the route of the labyrinth, to check that the design is correct.

Imagine...

Embedding a labyrinth within a mandala produces an enormously powerful tool for meditation. The spiralling pathway leads you toward your inner self, then takes you back again with renewed understanding of who you are spritually. As you embark on the finished artwork, imagine yourself walking the finished labyrinth.

First draw out the design in pencil, then go over the finished drawing in black ballpoint pen.

Handy Hint

Don't attempt to trace around the circular shapes with one stroke of the pen. Try holding the pen quite close to the nib so that it is easier to control. Then use short curved lines to build up each line that forms the circular shapes. Practice drawing flowing lines before inking in the final drawing.

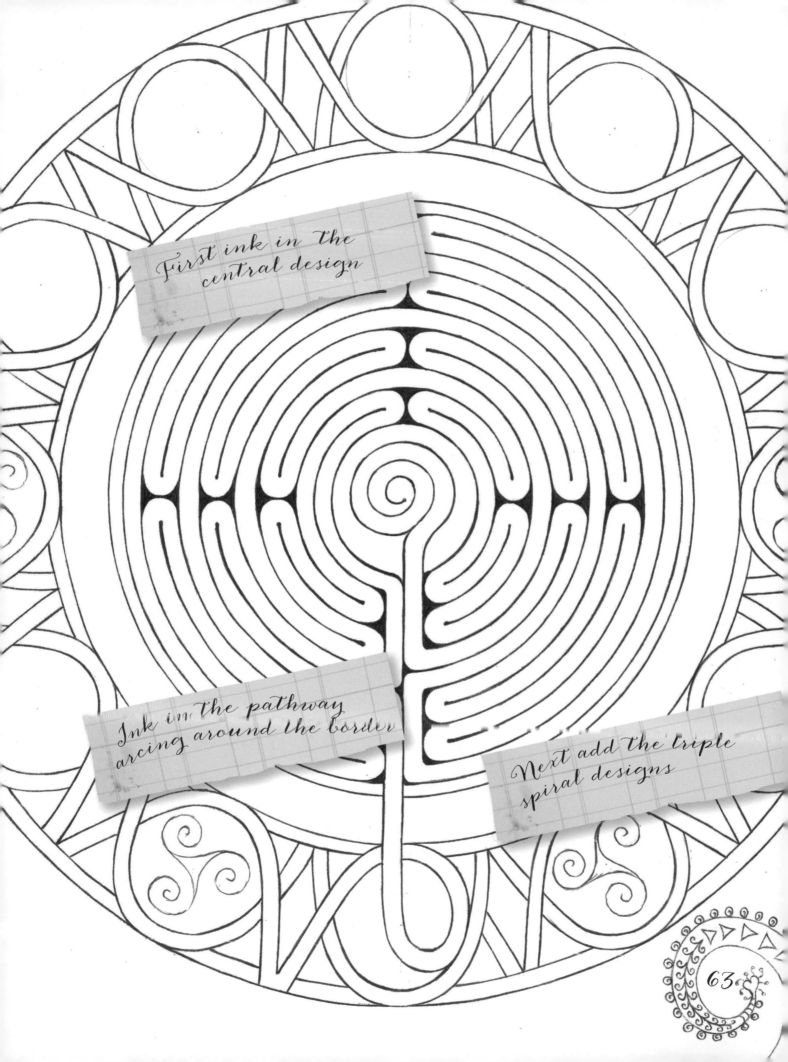

First ink in the central design

Ink in the pathway arcing around the border

Next add the triple spiral designs

63

Lose yourself

This strong design is best suited to simple Zen Doodle patterns such as dots and triangles. Start working outward from the center. Lose yourself in the joy of doodling as you decorate the path snaking its way around the labyrinth.

Use a darker color or pencil shading to give depth to areas of pattern.

To add contrast, leave a fine gap between the gold of the path and the black outline.

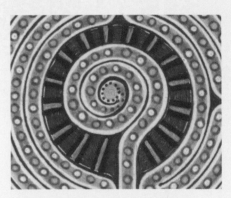

Black, red, and gold stripes focus inward to the center.

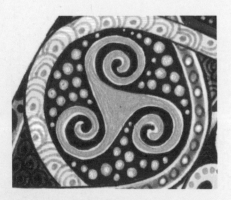

Experiment by using gold and silver gel pens.

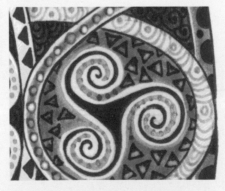

Try to vary the tonal value by doodling with pale gray on pale yellow.

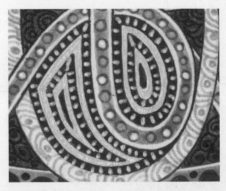

Finish each area of Zen Doodling before starting on the next.

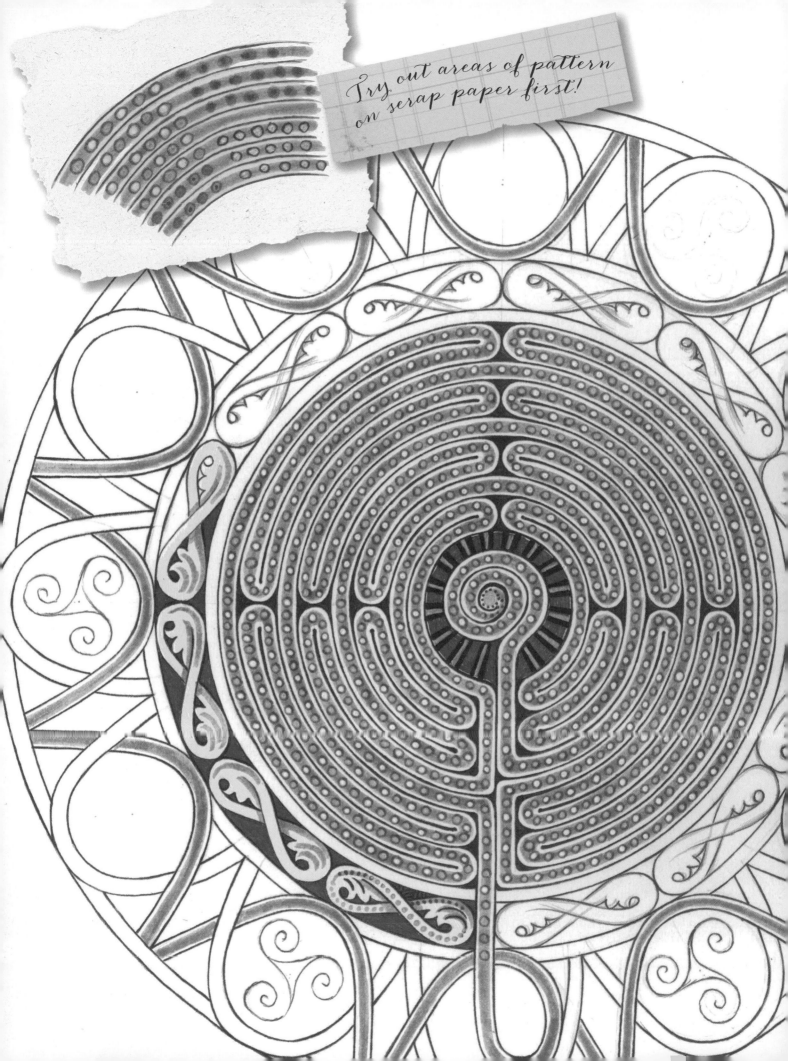

Try out areas of pattern on scrap paper first!

Creative border

This mandala could be further embellished by adding an unstructured border and background to its very formal design. Sponging is a simple and effective technique that creates exciting textures to Zen Doodle into.

Sponging

Take a sheet of thick cartridge paper, large enough to frame your design. Draw a circle slightly smaller than the mandala. Dab a sponge into gouache, then onto the paper. Try alternating the colors as you fill in the frame.

When the paint is dry, use gel pens to Zen Doodle the border. Try leaving a gap between the mandala and the frame design. Doodle in triple spirals in each corner of the paper, then fill the spaces with twirls and curls.

Carefully cut out your mandala. Use double-sided tape to stick it in place on the finished background.

Yin and Yang

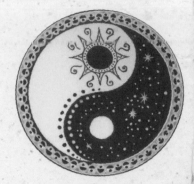

The ancient Chinese symbol of Yin and Yang represents the belief that everything in the universe consists of two forces that oppose and complement each other, thereby creating harmony and balance. The symbol of Yin and Yang is itself a mandala, and makes a bold, graphic central image for a more complex mandala design.

" When people see things as beautiful,
ugliness is created.
When people see things as good,
evil is created.

Being and non-being produce each other.
Difficult and easy complement each other.
Long and short define each other.
High and low oppose each other.
Fore and aft follow each other. "

Tao Te Ching [2]

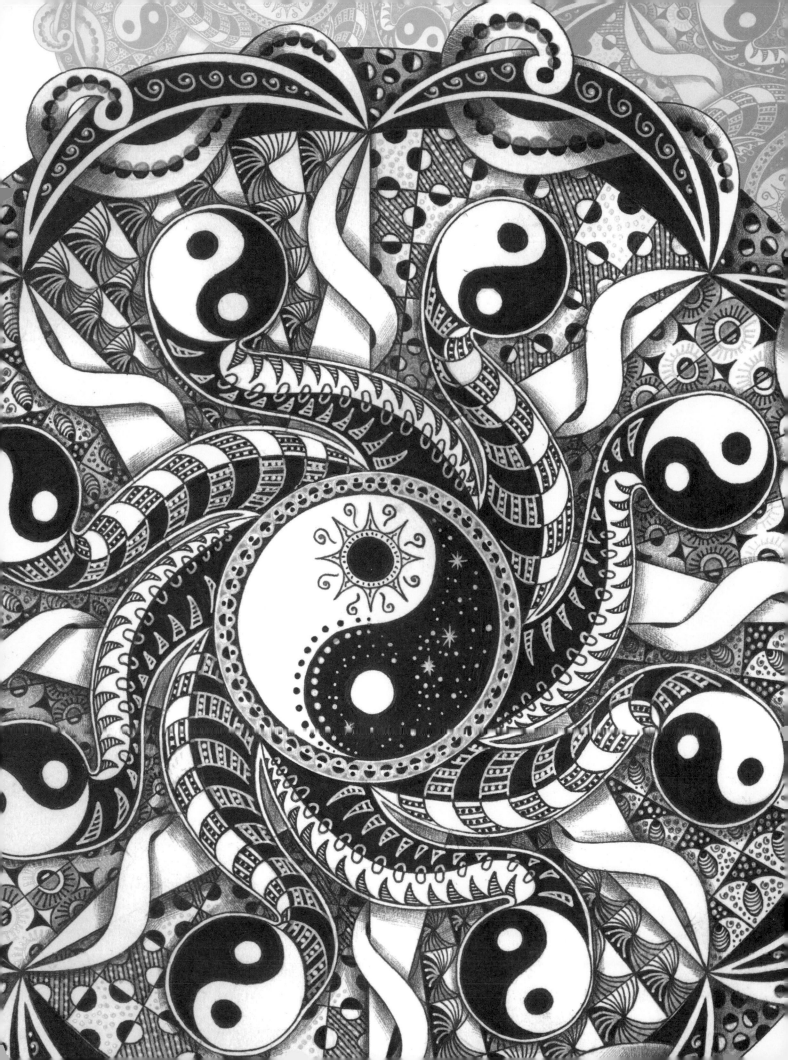

Opposites

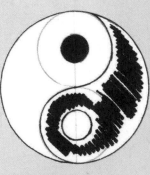

The Yin and Yang symbol comprises of a circle divided into two teardrop-shaped halves, one white and the other black. Each half contains a smaller circle of the opposite color so that in all Yin there is Yang and in all Yang there is Yin.

How to draw Yin and Yang

Step 1

Step 2

Step 3

Step 4

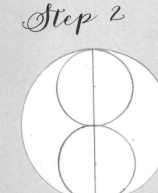

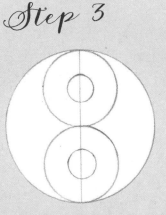

Use a compass to draw a circle. Draw a vertical line through the center point.

Draw two smaller circles, each half the radius of the large circle.

Add two tiny circles centered within these two circles.

Draw in an inverted "S" shape as shown around the top and bottom circles. Color in the black areas as above.

70

Make rough sketches of some different design ideas. Subtle changes in the composition can make a huge difference. Don't hurry this stage—it is important that you are happy with your design before you start working on the final image.

Day becomes night and then night becomes day...

Yang is white; it symbolizes light, the sun, and masculinity. Yin is black; it symbolizes dark, the moon, and femininity.

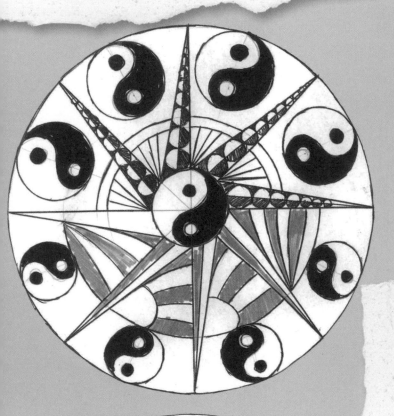

71

Harmony

The sweeping curves of the Yin and Yang symbol are echoed in this design. The pattern radiates out from the center and then draws one back in again. As Yin and Yang cannot exist without each other, this design relies on the balance between black and white to achieve harmony. Draw out your Yin and Yang mandala in a size you feel comfortable with.

Starting point

Keep your rough sketch nearby as you start work on your finished design. Use the rough only as a starting point—change and adapt it as you start Zen Doodling. The gray areas indicate where blocks of doodled patterns are to go.

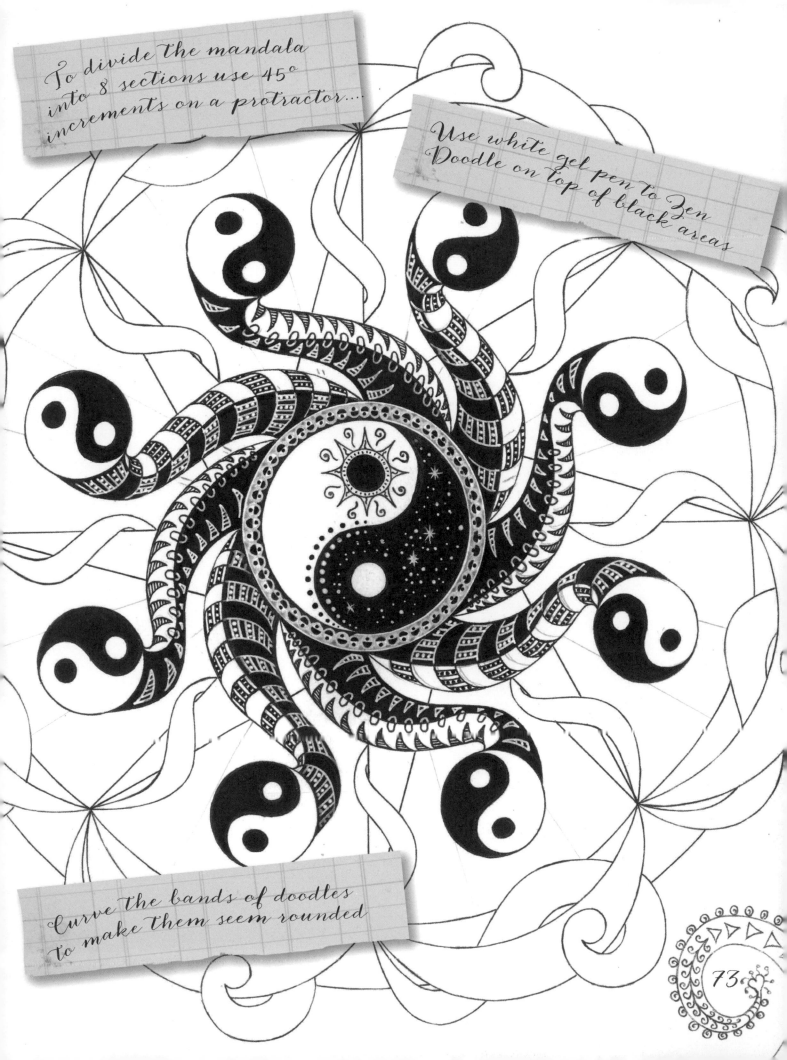

To divide the mandala into 8 sections use 45° increments on a protractor...

Use white gel pen to Zen Doodle on top of black areas

Curve the bands of doodles to make them seem rounded

Black and white

The nature of Yin and Yang is ever-changing. If Yin and Yang become unbalanced, too much of one can weaken the other. As you Zen Doodle think about areas of your own life that are normally in harmony and those aspects that are clearly black and white. Try to reflect your thoughts and feelings in your artwork.

Rough doodles

When Zen Doodling into complex compositions, it can sometimes be helpful to work out your doodles on scrap paper first.

Tone down contrasting areas by adding white gel-pen doodles to black areas and black doodles to white areas.

74

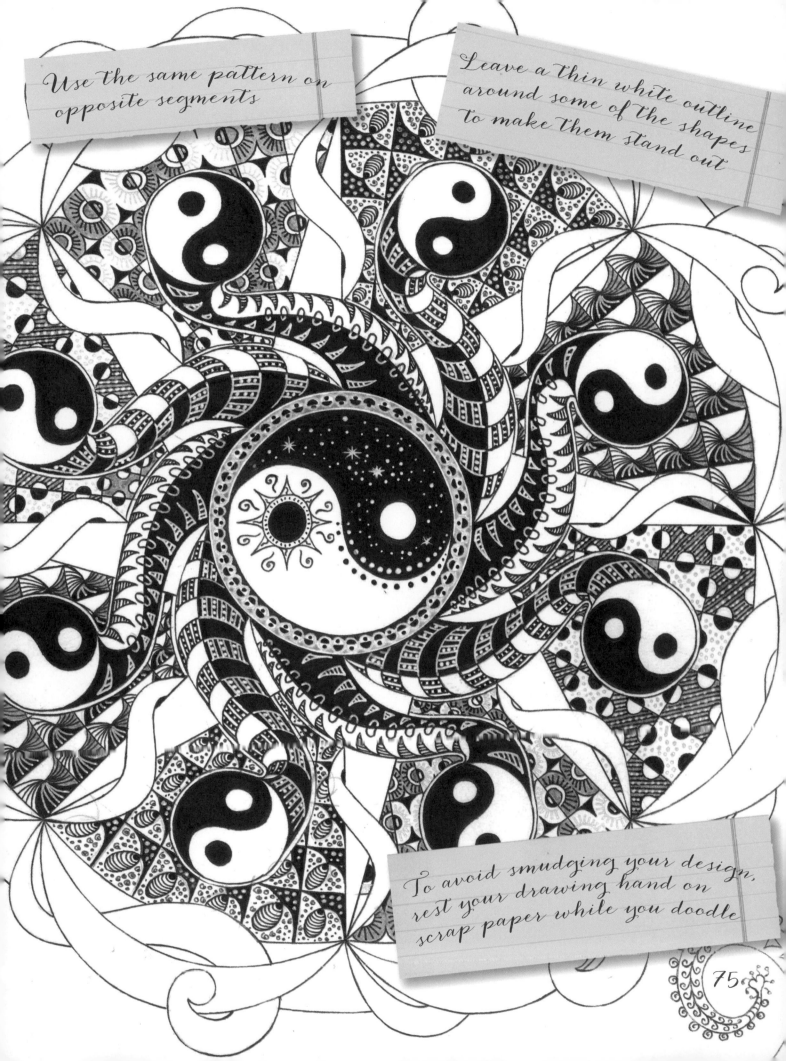

Use the same pattern on opposite segments

Leave a thin white outline around some of the shapes to make them stand out

To avoid smudging your design, rest your drawing hand on scrap paper while you doodle

Shadows

The unshaded right-hand side of this mandala looks flat and is less interesting, whereas the left-hand side has depth and vitality. First choose a direction for the light source, then add hatching and cross-hatching to create areas of shadow.

Handy hint

Experiment first by shading your original design rough before adding hatching to your final mandala. Try layering up the darker tones by using pencils and a ballpoint pen.

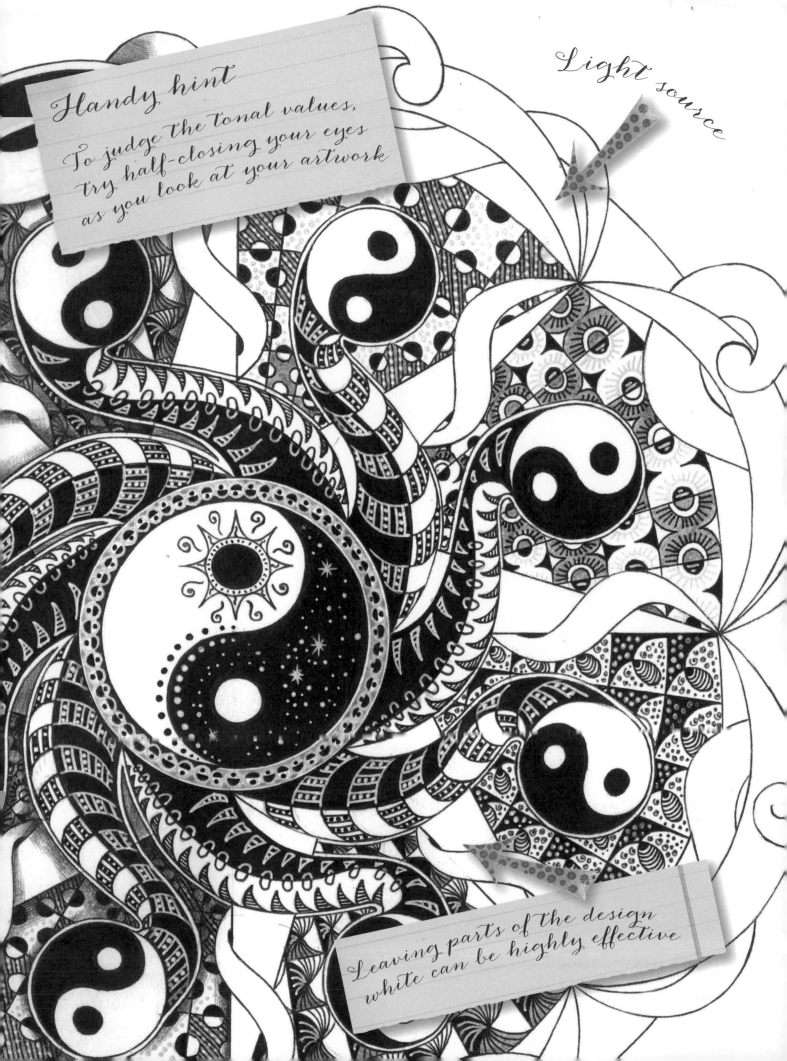

Handy hint

To judge the tonal values, try half-closing your eyes as you look at your artwork

Light source

Leaving parts of the design white can be highly effective

Dramatic effects

O nce your mandala artwork is finished, take time to appraise it. You may wish to create a dramatic background effect before framing it.

Colored ink wash

Method

Soak a sheet of watercolor paper for 2 minutes. Place on a drawing board, using a clean sponge to soak up excess water. Tape down all the edges of the paper. While the paper is still wet, use a large brush loaded with ink to paint a strip of color across the paper. Allow the ink to create random, exciting patterns. Leave to dry.

Carefully cut out your mandala artwork. Position it on the dry ink wash and use double-sided tape to stick it in place before you frame it.

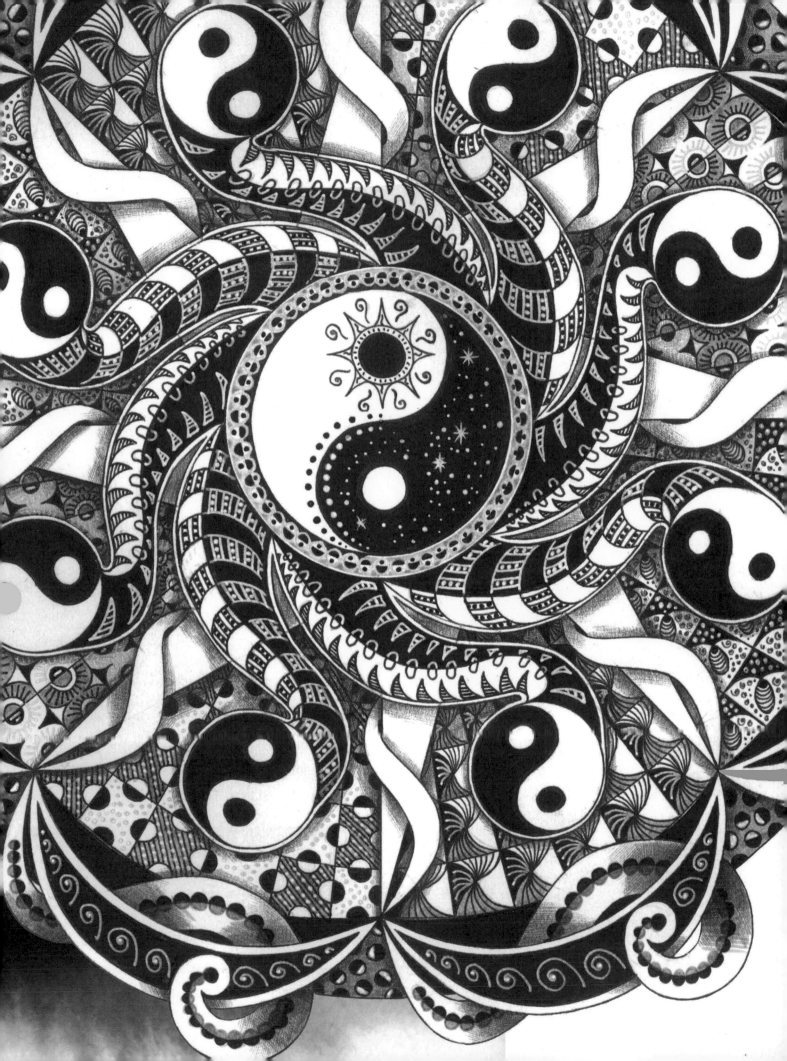

Earth and nature

Our incredible planet Earth gives us life; it nourishes and protects us. Earth and nature together maintain a delicately balanced ecosystem in which land, sea, climate, and all living creatures affect and mold each other. Think of the tremendous beauty of our planet, compare its strength and fragility, and consider the amazing diversity of life it sustains. Let nature be at the very heart of your creativity when Zen Doodling your mandala.

> "My heart leaps up when I behold
> A rainbow in the sky:
> So was it when my life began;
> So is it now I am a man;
> So be it when I shall grow old,
> Or let me die!"
>
> *William Wordsworth*

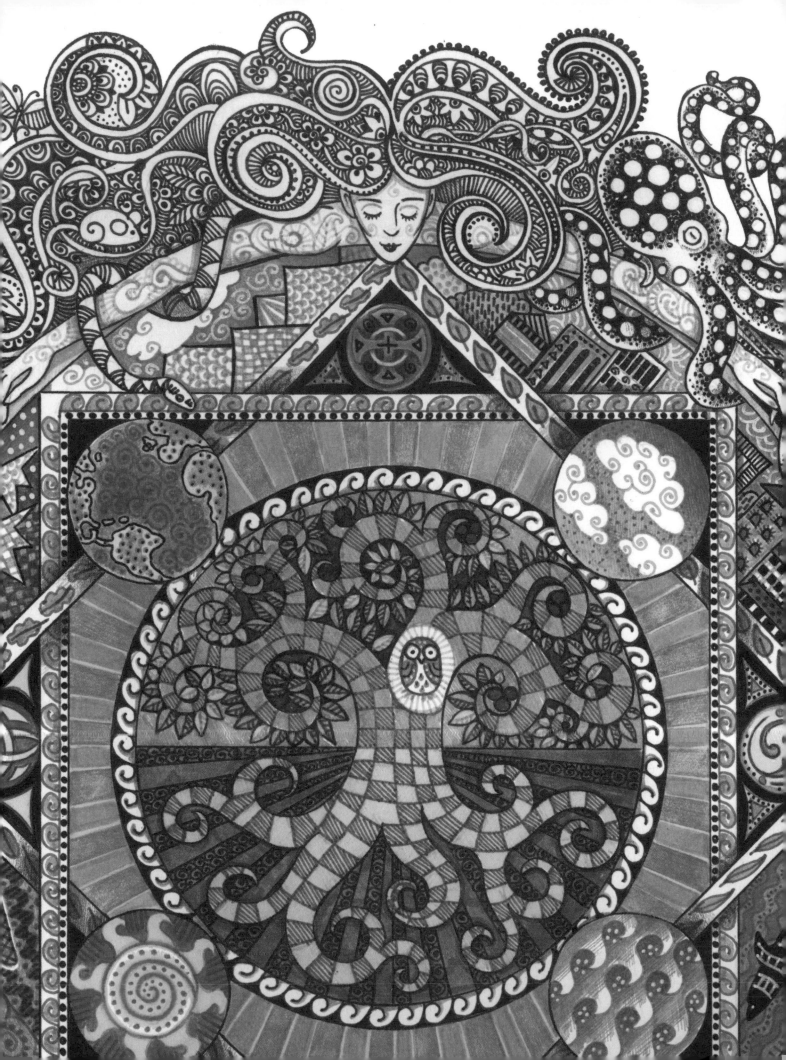

Bold design

egin by thinking of the different elements you wish to include in your design. Picture in your mind the finished mandala, then start making thumbnail sketches of your ideas. For example, the Tree of Life is a powerful central theme, and the image of Mother Earth wrapping her arms protectively around the border creates a strong design to frame the mandala.

List of ideas:
The Tree of Life
Mother Earth
Symbols of earth, air, fire, and water
Seas and oceans
Fish, birds, reptiles, mammals, insects, etc.
Different landscapes, cityscapes, etc.

Thumbnails

Mother Earth

Tree of Life

Life on Earth originated in the oceans. They cover seven tenths of the planet's surface. Celebrate the seas and oceans by creating a border of waves. Try to incorporate some of the stunning creatures that live there: seahorse, octopus, whale, and so on.

Octopus

Seahorse

Shark

Whale

It's a good idea to make a large color rough for a complex design

Monochrome

By contrasting areas of monochrome Zen Doodles with those in full color, you can produce visually stunning results. In this design, the border is black and white, in stark contrast to the vibrant colors of the inner mandala.

Use a pencil to draw your finished design, then ink in the main outlines with a fine liner or ballpoint pen. Erase any pencil marks.

Perfect structure

Mother Earth's long, flowing tresses provide the perfect structure for some fantastic Zen Doodle patterns! Entwined in her hair can be as many of your favorite creatures from the animal kingdom as possible: mammals, reptiles, insects, beetles, and so forth.

Doodle this rabbit with flowers

These tentacles make wonderful, flowing shapes to doodle!

Practice first...

Practice drawing any complicated parts of your composition on scrap paper. *Tip*: working to the same scale as the design means that your sketches can be traced directly onto your final artwork.

85

Interpretations

B efore Zen Doodling the finished artwork, make photocopies of your design outline. Think of different visual possibilities to interpret your ideas, then try out these options on the copies. This process is tremendous fun, because you can try out different ideas, color schemes, and techniques without the anxiety of spoiling your finished design.

Photocopies

The design inside the border is based on a theme of animal patterns.

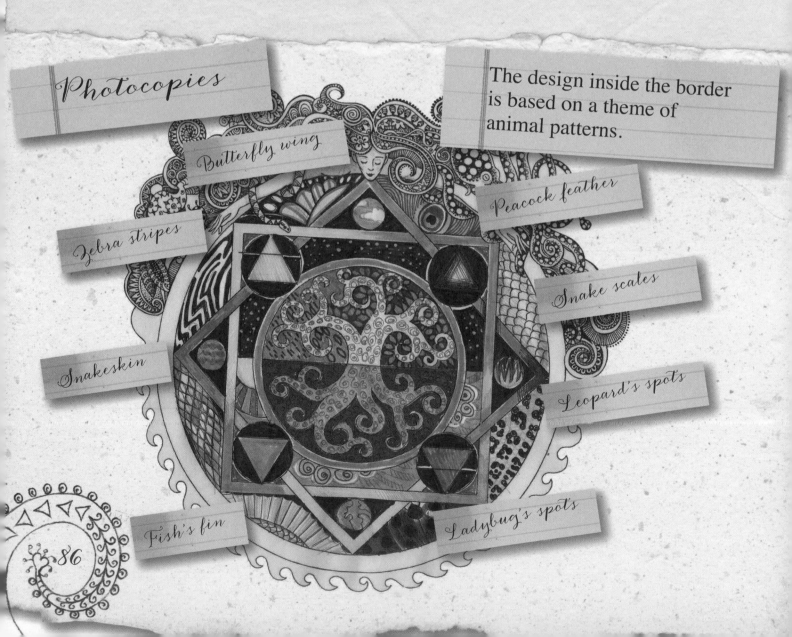

Butterfly wing

Zebra stripes

Peacock feather

Snake scales

Snakeskin

Leopard's spots

Fish's fin

Ladybug's spots

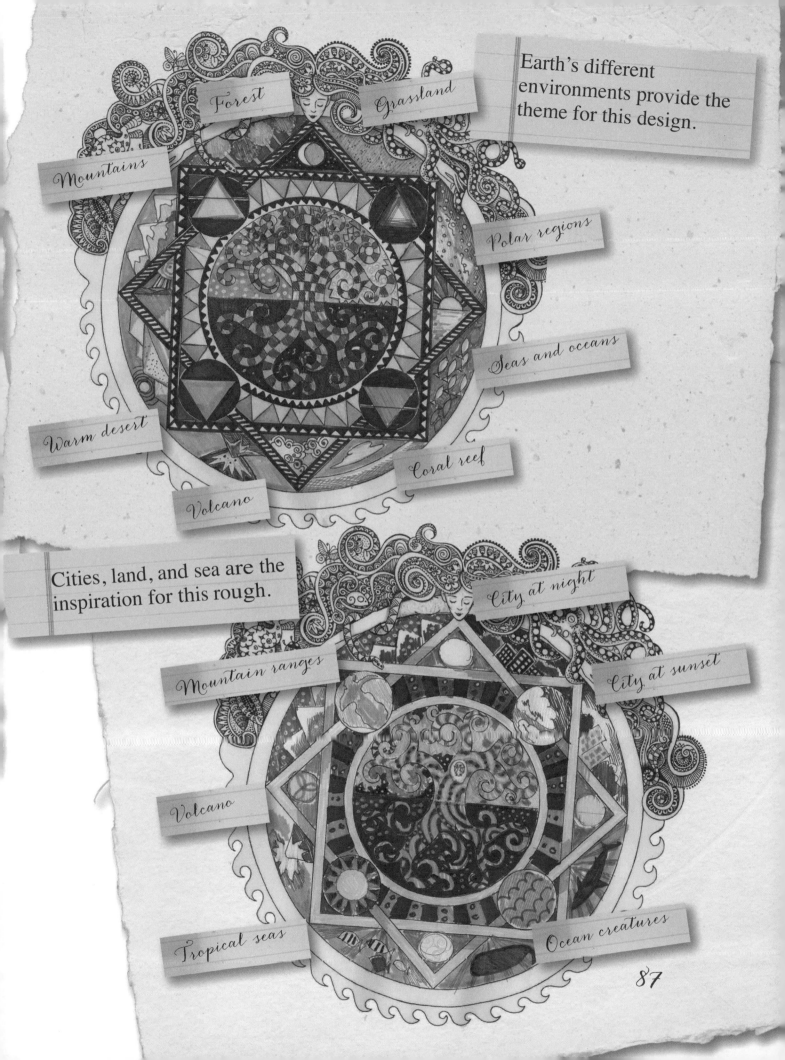

Forest

Grassland

Earth's different environments provide the theme for this design.

Mountains

Polar regions

Seas and oceans

Warm desert

Coral reef

Volcano

Cities, land, and sea are the inspiration for this rough.

City at night

Mountain ranges

City at sunset

Volcano

Tropical seas

Ocean creatures

87

Tree of Life

The Tree of Life is a powerful symbol, used by many cultures around the world. The three main constituents of a tree—its trunk, branches, and roots—are comparable to a person's body, spirit, and psyche. The tree, as it reaches upwards in search of sunlight, reflects our personal struggles and aspirations—our desire to reach for enlightenment. The Tree of Life symbol represents qualities such as wisdom, strength, beauty, bounty, protection, and redemption.

Start at the center

Use or adapt some of the patterns and color schemes from the previous pages to doodle the center of your mandala.

Consider the tonal value of the design as you work. The roots are colored light yellow and ginger to stand out from the dark brown and black background.

Earth, air, fire, and water

In ancient times, the entire universe was seen as consisting of the four elements: earth, air, fire, and water. Incorporate a set of Zen Doodled symbols within the mandala.

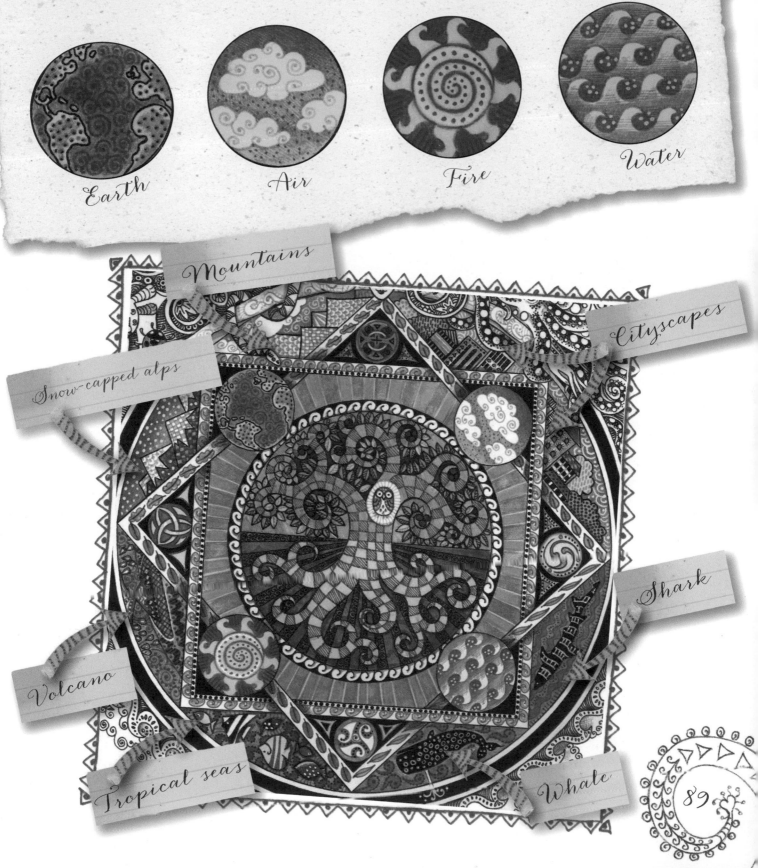

Earth

Air

Fire

Water

Mountains

Cityscapes

Snow-capped alps

Shark

Volcano

Tropical seas

Whale

Creating texture

If you feel your finished mandala should have a background, put your artwork safely to one side, then start experimenting! It is particularly exciting and liberating to Zen Doodle into and around random textures. One of the easiest and most effective techniques aptly combines watercolor with salt—the prime ingredients of our oceans!

Watercolor and salt!

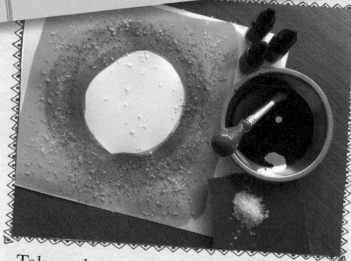

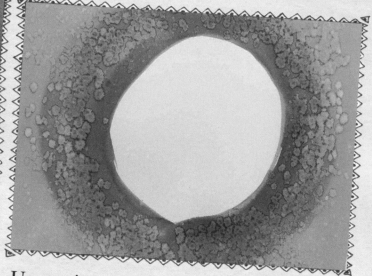

Take a sheet of thick cartridge paper large enough to frame your design. Draw a circle slightly smaller than your mandala. Use a large paintbrush to apply diluted watercolor (concentrated liquid watercolors were used here).

Use a piece of tissue to soak up any puddles. While the paint is still wet and shiny, liberally sprinkle it with rock-salt crystals. Once dry, brush off the salt to find a delicate pattern of pale spots and watermarks to doodle.

Draw a circle around the outside edge of the border, encasing some of the design and letting other parts overlap it.

Fill in the new border with black pen. Carefully cut out your mandala.

Use double-sided tape to stick your mandala to the background.

The heart and love

Love is an infinitely powerful emotion. Using symbols to represent its various aspects enables us to focus on, and then explore, our personal experiences of love. The symbol of a heart shape originally evolved from that of an upturned triangle, which itself has symbolic meanings of femininity and water. In the past, the heart shape was used in spells and rituals to unite lovers and strengthen romantic bonds. More recently, the heart has also come to symbolize love in general: joy, attraction, compassion, and unity.

> « Being deeply loved by somebody gives you strength, while loving someone deeply gives you courage. »
>
> Lao Tzu

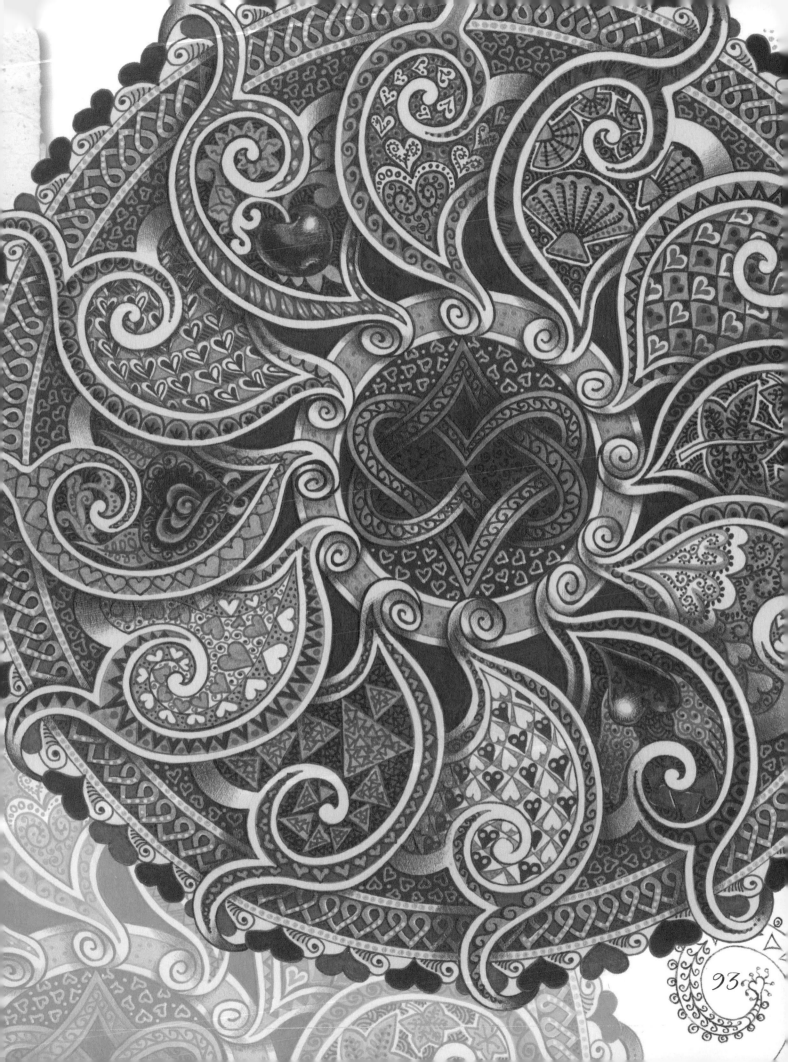

Bold border

Try using the heart shape in as many different ways as possible in your design. Large heart shapes can make a bold and striking border design around the central motif. Experiment by drawing them at an angle. Study the gaps in between the shapes you've drawn and use them as an integral part of the design. Do rough sketches of different versions of the composition.

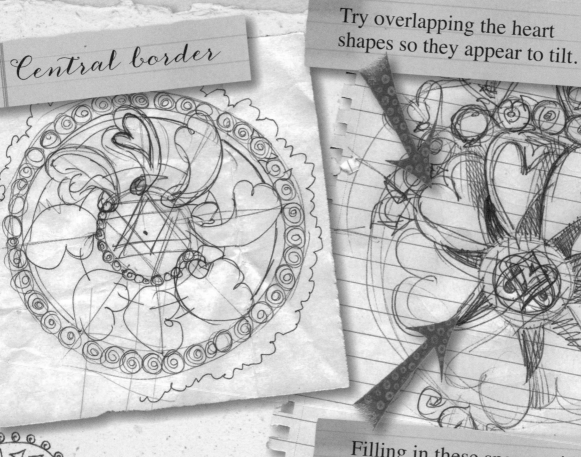

Central border

Try overlapping the heart shapes so they appear to tilt.

Filling in these spaces with black makes the heart shapes stand out.

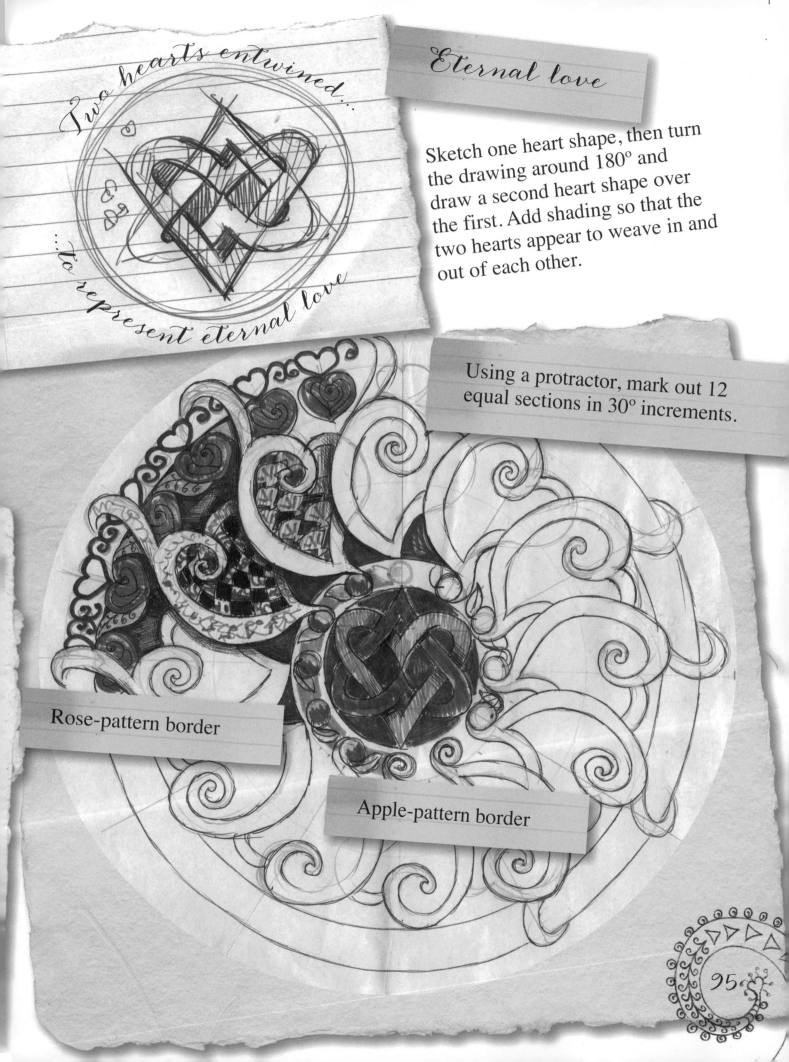

Two hearts entwined...

...to represent eternal love

Eternal love

Sketch one heart shape, then turn the drawing around 180° and draw a second heart shape over the first. Add shading so that the two hearts appear to weave in and out of each other.

Using a protractor, mark out 12 equal sections in 30° increments.

Rose-pattern border

Apple-pattern border

Symbols of love

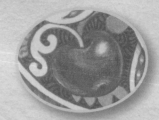

Roses, shells, maple leaves, apples, Cupids, harps, and triangle shapes are just some of the symbols commonly used to depict love. Relax! Think of the symbol you wish to doodle and have fun exploring the different Zen Doodles you can create.

Heart-shaped roses

Use your sketchbook or some scrap paper to experiment. Draw in a grid, then design some repeating patterns based on heart shapes.

Doodles based on a shell

Felt-tips and gel pens

Reds of every hue

ather together a range of media in all shades of red. Include orange, red-orange, peach, fuchsia pink, red-purple, and purple. *Note*: Layering a darker color on top of a lighter one creates depth of color. Doodling a contrasting color over the top of another affects both the color of the doodle and the overall color of the area of patterning.

Hearts entwined

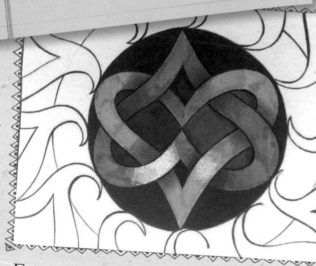

For a powerful central image, use a rich, vibrant pink and orange to color the hearts. Add shading and highlights to give the effect that the two hearts are entwined.

Zen Doodle the black background with silver gel pen, then doodle the hearts.

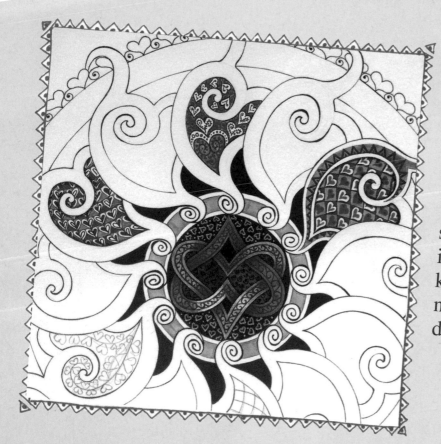

Use a black marker pen to fill in any black areas. Then start filling in the center of each alternate heart shape with Zen Doodled heart patterns. Use as many different shades of red as possible in your doodles. Try keeping to mid-tones, neither too light nor too dark.

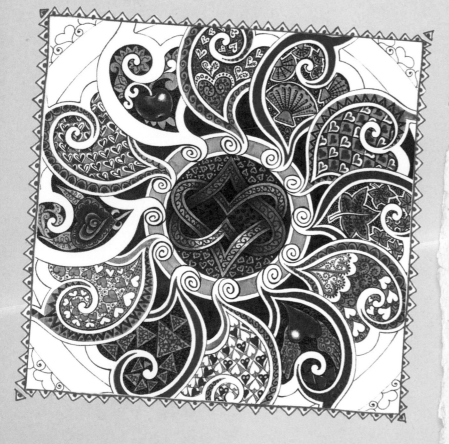

Use the patterns previously designed to Zen Doodle the six remaining heart shapes.

Have scrap paper handy for trying out different combinations of materials, colors, and patterns.

Adding depth

Thermometer These heart shapes appear to lift off the page and lead your eyes directly towards the center of the mandala. Many complex designs benefit from areas left free from doodles. Plain black and white shapes act as a dramatic foil to the elaborate patterns and provide tonal contrast.

Visual illusions

Practice adding shade to your original rough using a range of materials. Try smudging pencil hatching with your fingertip. Experiment with a black ballpoint pen to add cross-hatching. Black pencil crayon scribbles create interesting textures. Find and use whatever combination of mediums and techniques works best for you.

Pencil and ballpoint pen

Pencil hatching

Black and gray fine liner pens

Scribble technique using pencil crayon

Before...

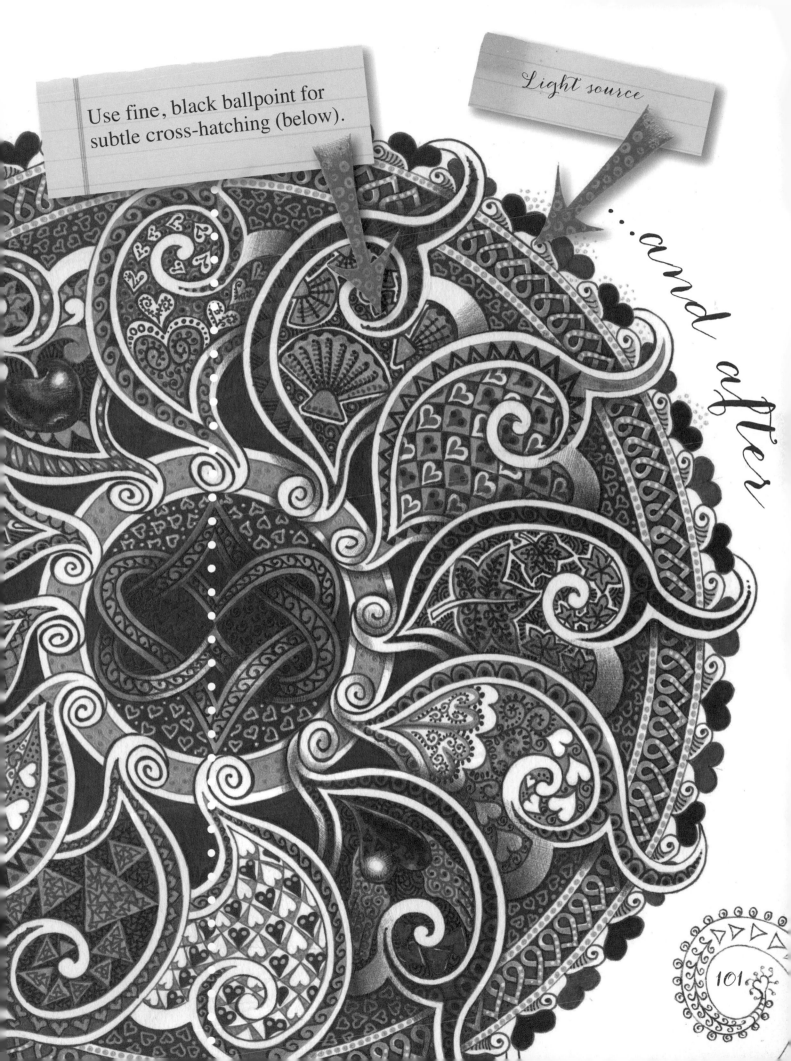

Use fine, black ballpoint for subtle cross-hatching (below).

Light source

...and after

101

Lace effect

In the days of chivalry, if a maiden dropped her handkerchief in front of a man, it implied that she liked him. If the man then picked it up, the pair were permitted to meet. Ladies' handkerchiefs were usually trimmed with lace, so they came to be associated with love and romance!

Stenciling

Take a large sheet of black paper. Draw a circle slightly smaller than your mandala. Use paper doileys (or scraps of lace) as stencils. Holding the stencil firmly in place, dab gold or bronze gouache through it using a large brush.

Lift off the stencil and repeat the process until the paper is covered. Leave to dry. Use gold and bronze gel pens to Zen Doodle lacelike patterns around the stenciled shapes.

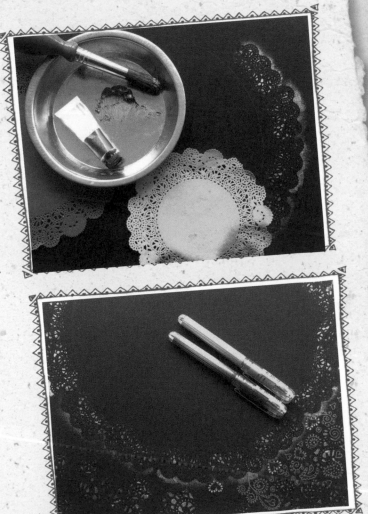

102

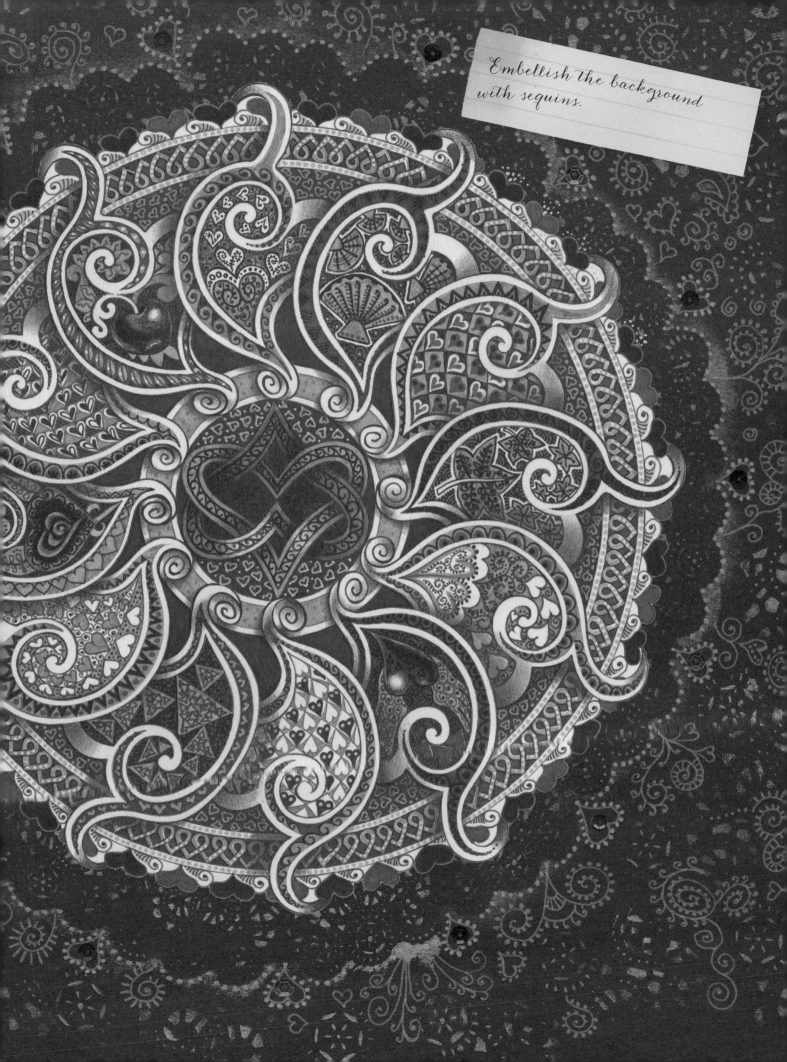

Embellish the background with sequins.

Spiral

The earliest known spiral shapes were carved on rocks by primitive man. Since then, the spiral has been used as a positive symbol by cultures throughout the world. It has been seen to represent spiritual development or, indeed, our identity with the universe. Spirals have a strong association with the dynamic cycles of life: the metamorphosis from birth to growth, death, and, finally, rebirth.

> "What is art but life upon the larger scale, the higher. When, graduating up in a spiral line of still expanding and ascending gyres, it pushes toward the intense significance of all things, hungry for the infinite?"
>
> *Elizabeth Barrett Browning*

Allow the spiral shape to reflect the changing direction of your own journey through life. Keep this idea in your mind as you work on your design.

Spirals in nature

Spiral shapes pattern our very existence, from the minute vortices of subatomic particles to spiraling galaxies billions of light years away. Spirals can be found throughout nature: in weather systems, whirlpools, bird flight patterns, plant growth, and in the structure of our own bodies.

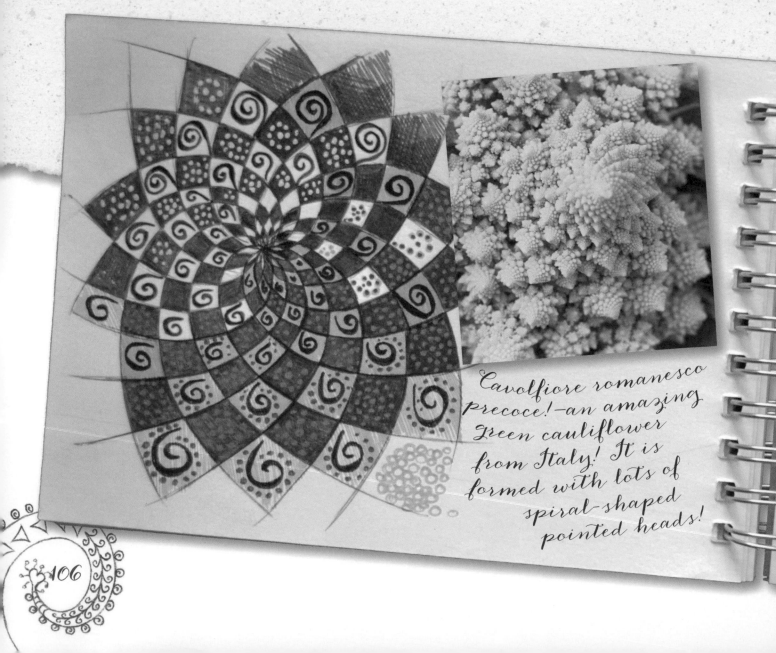

Cavolfiore romanesco Precoce!—an amazing green cauliflower from Italy! It is formed with lots of spiral-shaped pointed heads!

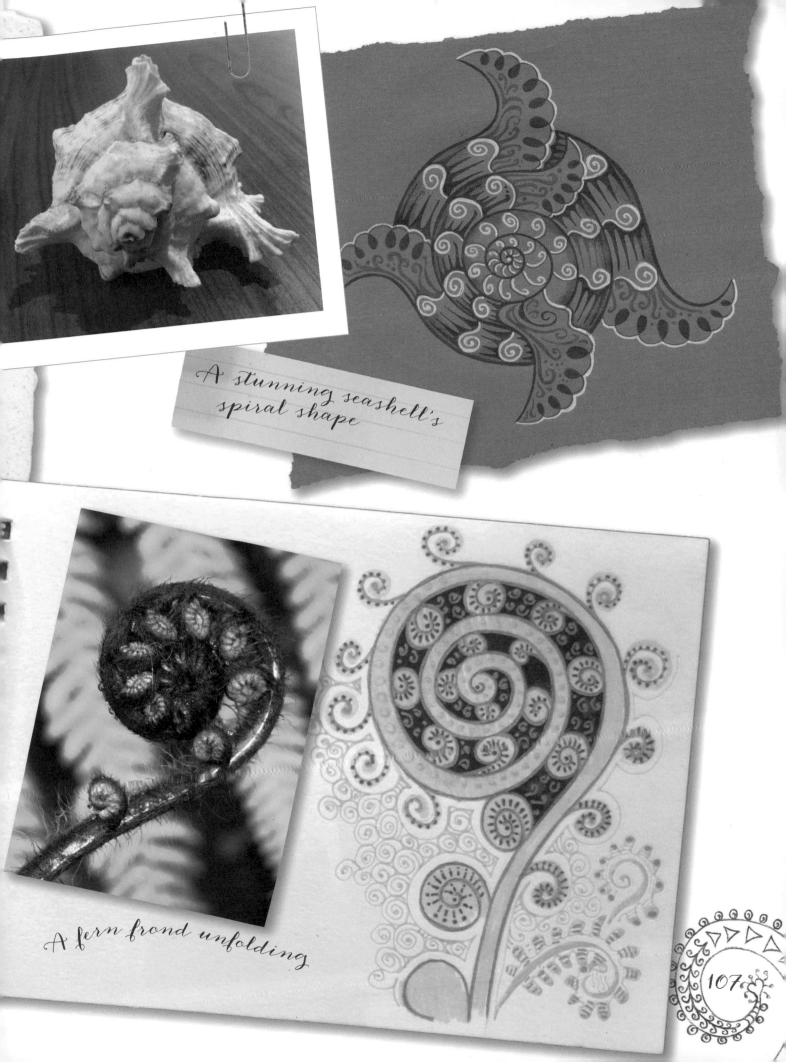

A stunning seashell's spiral shape

A fern frond unfolding

Sunflower Theme

The spiraling patterns of a sunflower make a fantastic theme for a mandala design. Experiment by using spiral shapes in your composition in as many ways as possible. Take the basic components of a sunflower and try to reassemble them in a spiral.

Repeating spirals

Try working on colored paper...

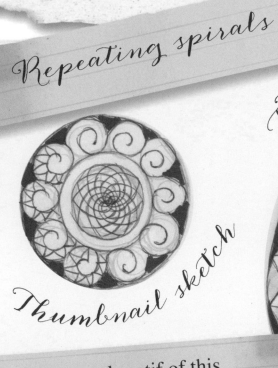

Thumbnail sketch

Color rough

The central motif of this mandala design is based on the spiral pattern of a sunflower head. The surrounding border has nine spirals, each decorated in sunflower petals.

Thumbnail sketch

Try sketching a spiral-shaped sunflower. Work outwards from the center of the seed head, then add a swirl of petals.

Add depth and contrast by applying dark green behind the petals.

Color rough

How to draw a spiral

This simple and easy method to draw a basic spiral shape uses a series of concentric circles as guides. Equidistant concentric circles produce a spiral of regular width. The width of the spiral below gets progressively wider, which requires increased spacing between the circle guides.

Draw guides

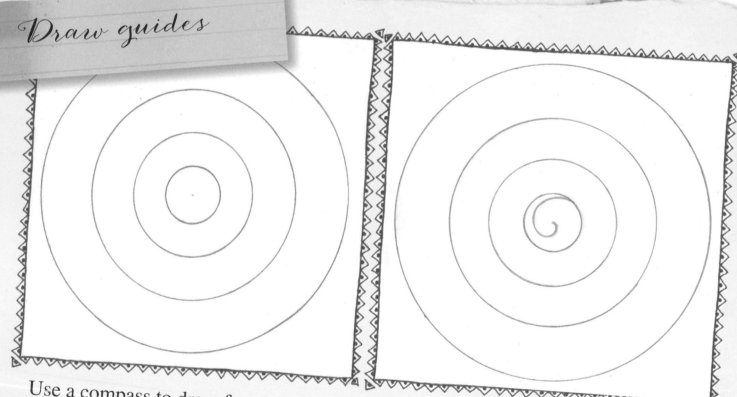

Use a compass to draw four concentric circles. Make each radius progressively larger—for example, 1 in. (2.5 cm), 2.5 in. (6 cm), 4.5 in. (11 cm), and 7 in. (17.5 cm).

Draw a curved line from the center of the first circle out toward its circumference, as shown.

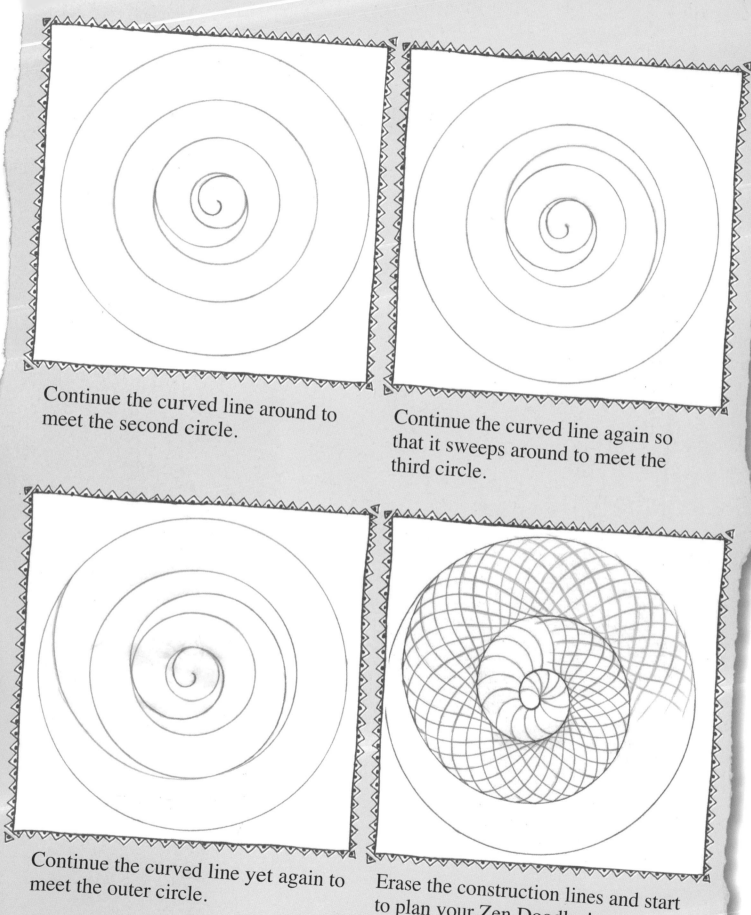

Continue the curved line around to meet the second circle.

Continue the curved line again so that it sweeps around to meet the third circle.

Continue the curved line yet again to meet the outer circle.

Erase the construction lines and start to plan your Zen Doodles!

Sunshine

unflowers exhibit heliotropism—they turn their heads to follow the sun's movement across the sky. Their petals are vivid yellow—the color associated with sunshine, happiness, energy, and intellect. Bright yellow attracts attention and implies spontaneity and openness.

Use shades of yellow

Try out complicated patterns on scrap paper. Choose a color scheme.

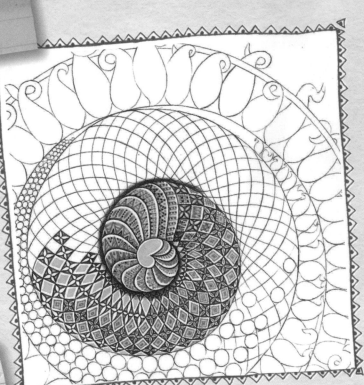

Use a pencil to draw out your final design, then ink it in with a black ballpoint or fine liner pen. Now start Zen Doodling!

Color in the petals with yellow watercolor paint or felt-tip pen. Add areas of orange blending into yellow.

Use a black fine liner pen to doodle onto the orange part, then use brown or red to doodle the yellower areas.

Zen Doodle over the dark green areas with a black fine liner pen.

Outline the petals with orange fine liner pen, then add shading. Use different doodles on each petal.

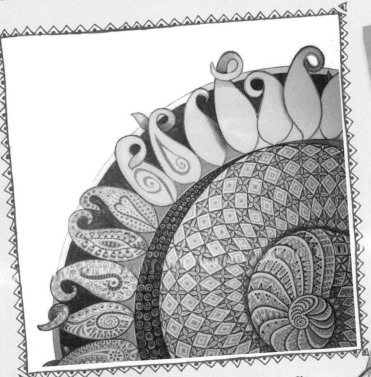

Frame your mandala

Add impact to your mandala by doodling a wonderful frame for it! The leaves of a sunflower make an ideal theme. To unify the artwork, color in the frame using similar shades of green to those used in the main image.

Make a thumbnail sketch of your mandala, then add a design in each corner.

Trace the design

Draw a square (slightly larger than your mandala). Draw a circle to fit the square. Sketch in three leaves with entwined stems.

Trace the design onto the other three corners. Use watercolors to paint a light background wash. Once dry, paint the leaves.

Now Zen Doodle the four corner designs. Keep the colors and tonal values muted so that the frame enhances the mandala rather than detracting from it.

Snowflake

Snowflakes are exquisitely intricate forms of frozen water. Water falling as snow or rain can be interpreted as a flow of energy from a higher spiritual plane to a lower one. Snow symbolizes purity and innocence. When snow falls, it often transforms a landscape, making beautiful much that is ugly. It brings with it a sense of tranquility and a strange, reverential silence. Keep these thoughts uppermost in your mind as you embark on your snowflake mandala.

"Begin doing what you want to do now. We are not living in eternity. We have only this moment, sparkling like a star in our hand—and melting like a snowflake."

Sir Francis Bacon

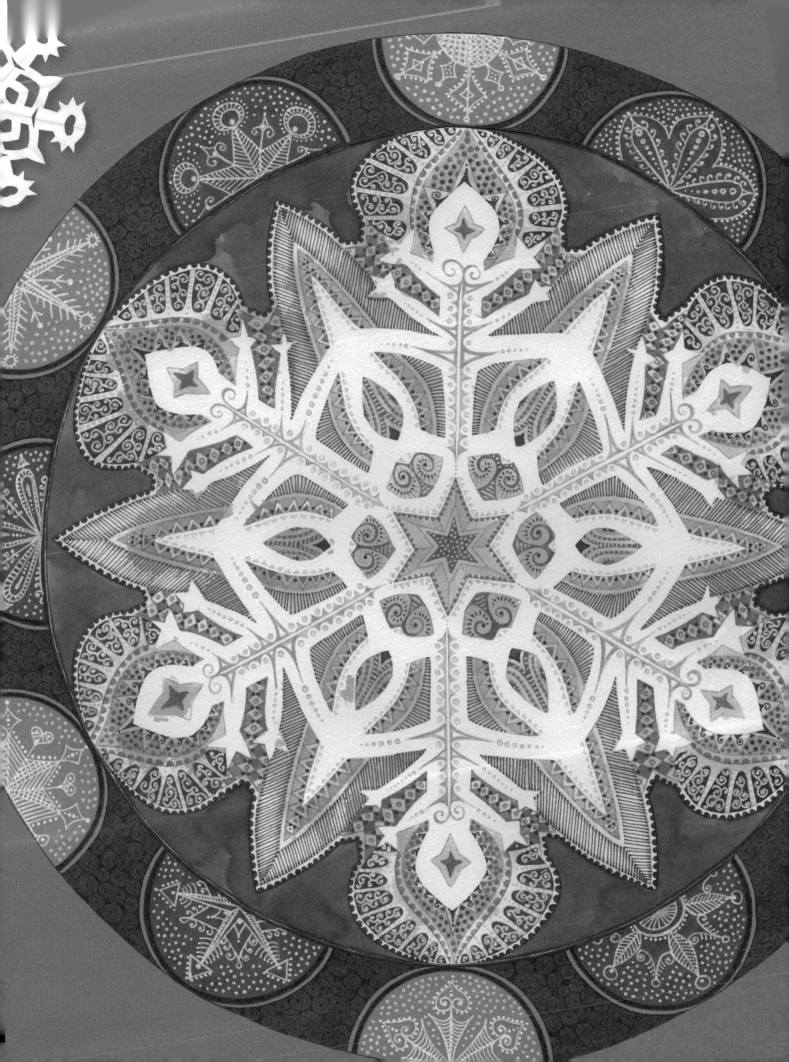

Making templates

Creating six-pointed paper snowflakes is not only terrific fun—the finished results make ideal templates for snowflake mandalas.

Paper snowflakes!

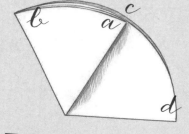

Fold a circle of white paper in half. Using a protractor, measure 60° and 120° from point (*d*).

Take (*a*) up to (*c*) and fold.

Take (*d*) up to (*b*) and fold.

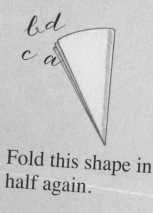

Fold this shape in half again.

Sketch a snowflake design on your folded paper. Use small, sharp scissors to cut it out.

These three designs produce quite different snowflake patterns (below).

(1)

(2)

(3)

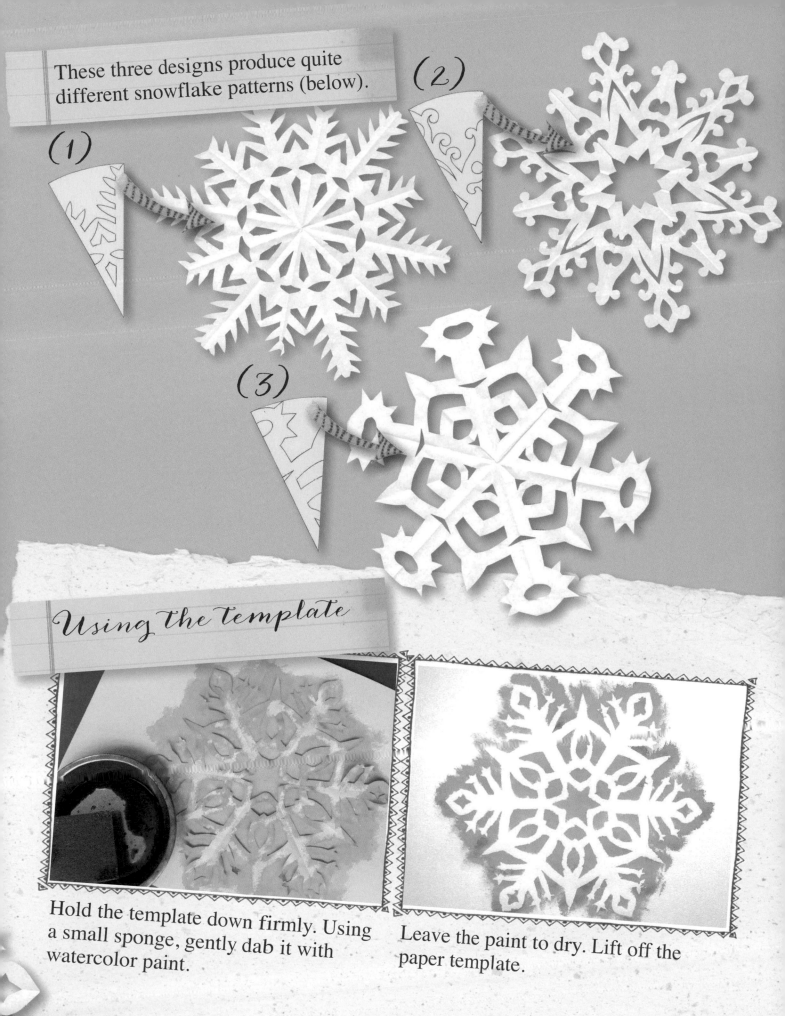

Using the template

Hold the template down firmly. Using a small sponge, gently dab it with watercolor paint.

Leave the paint to dry. Lift off the paper template.

Tonal value

A white snowflake provides the central structure for this mandala design. The colors associated with ice and snow are all pale: they are shades of light blue, turquoise, pale gray, and silver. To give strength and impact to the overall design, it is important to build in bold areas of tonal value.

Mid-tones

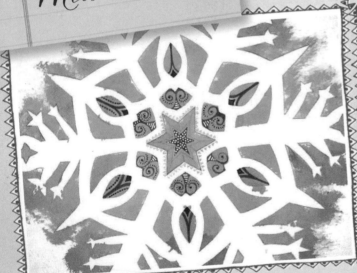

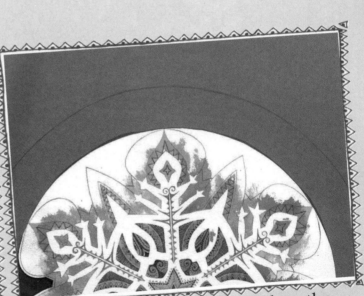

Start doodling the center of the snowflake. Use predominantly mid-tones of blue with an occasional darker blue to highlight particular areas.

Draw a circle slightly larger than the snowflake, then cut it out. Mount the design on a large sheet of blue-gray paper or card to add tonal contrast. This will make the white snowflake really stand out!

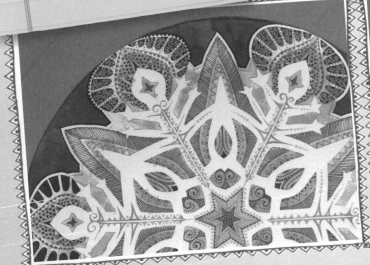

Use dark blue watercolor paint or a felt-tip pen to fill in the outer border, as shown. Doodle on top of the dark areas with silver or white gel pens.

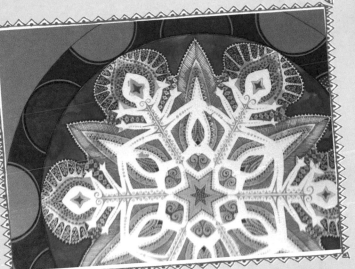

Create a new border by drawing a larger circle around the big snowflake design. Draw a pattern of alternating semicircles around the border.

Block in the main shapes using various tones of gray. Use a white gel pen to Zen Doodle a different snowflake design on each semicircle.

Pale gray (paper)

Dark gray

Mid-gray

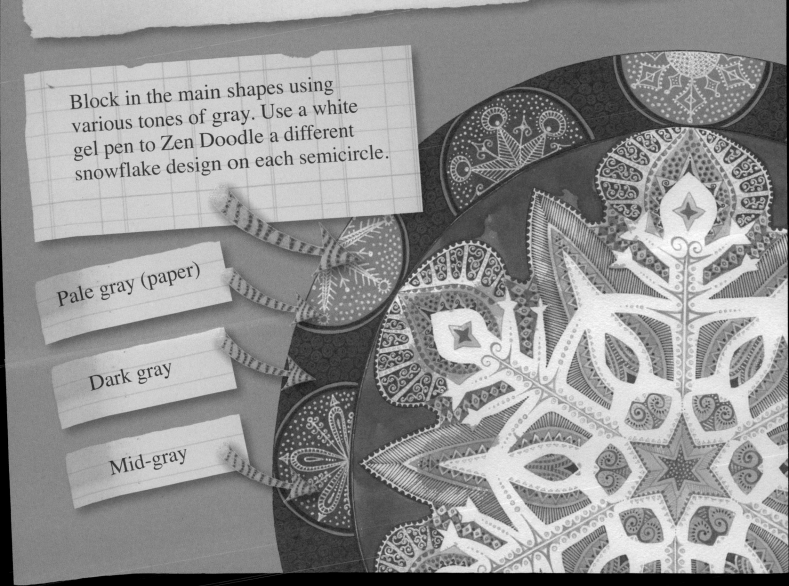

Indenting

This easy technique produces fabulous results. It's best to Zen Doodle very simple patterns such as straight lines, triangles, and curls. The finished designs make wonderful seasonal decorations and gifts!

Simple templates

Follow the instructions on page 118 to make some small, very simple paper templates of snowflakes.

Using a pencil, trace the shape of each snowflake onto thick white cartridge paper. Then indent Zen Doodle patterns onto the snowflake shapes using an empty ballpoint pen (press down firmly).

Using a soft pencil crayon, lightly shade over the entire snowflake. The indented patterns will appear as white lines. Carefully cut out the finished snowflakes.

Color in each snowflake design using a selection of blue, green, or purple pencil crayons.

The bigger picture

This snowflake mandala design lends itself to being part of a bigger picture. Mount it on a large sheet of colored paper or card, then embellish it with small indented snowflake designs to give the effect of falling snow.

Composition

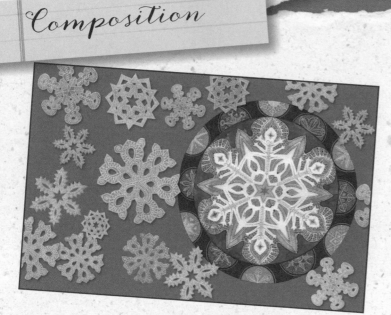

A circular mandala framed in a square format works extremely well. However, a rectangular format can be equally effective, as in this example (left).

Useful Tips

(1) When composing a picture, vary the size of the different elements that make up the entire image.

(2) Try placing the main image off center, and use the other components to create balance and add interest.

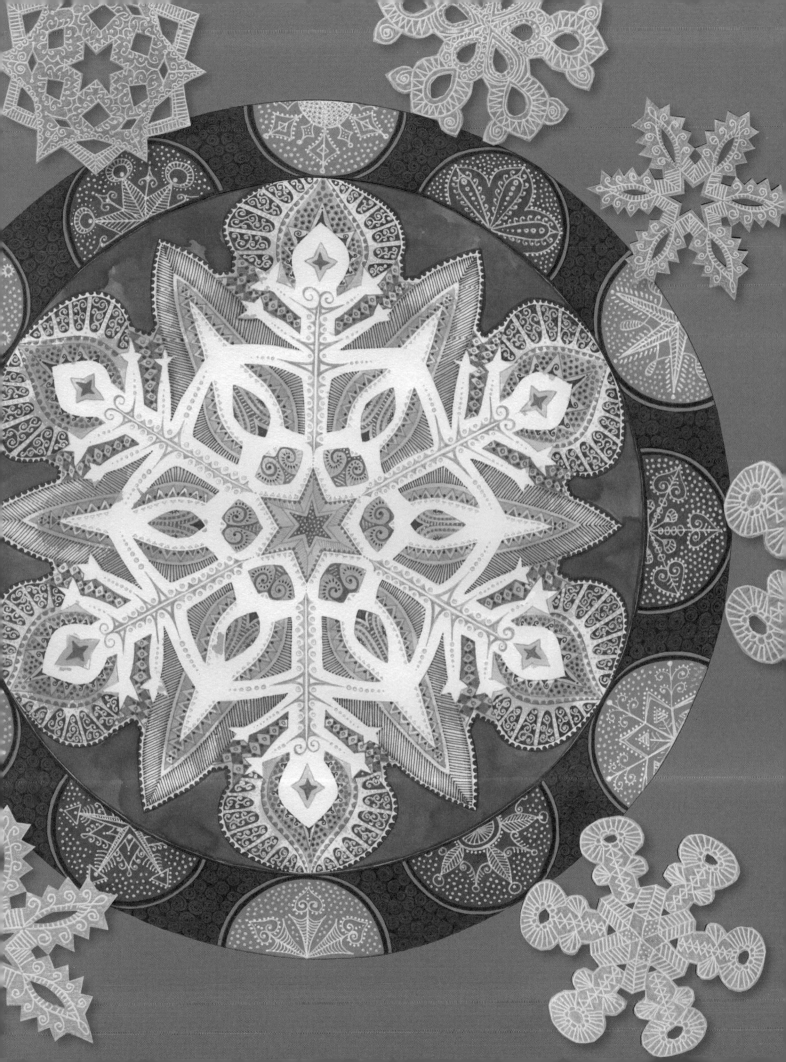

Glossary

Ammonite an extinct marine animal with a beautiful, ribbed spiral shell.

Analogous colors harmonious colors that lie next to each other on the color diagram (page 16).

Asymmetry when the two halves of a design don't match or are unequal.

Circumference the boundary line of a circle.

Color temperature the coolness or warmth of a color (blue-green is coldest and red-orange is warmest).

Compass instrument for drawing circles and arcs.

Composition the arrangement of the main parts of an image so as to form a unified whole.

Concentric circles different sized circles sharing the same center point.

Cross-hatching shading technique using two or more sets of intersecting parallel lines.

Deconstruct to break down a pattern into simple components.

Design a graphic representation, usually a drawing or a sketch.

Enlightenment the state of having spiritual knowledge or understanding.

Equidistant equally distant.

Gyre a circular or spiral form.

Harmonious colors a pleasing arrangement of colors.

Hatching shading technique using a series of parallel lines.

Heliotropism the growth of plants in response to sunlight, so that they turn to face the sun.

Labyrinth a single winding path leading from outside to the center.

Light source the direction from which light originates.

Limited palette a restricted number of colors used in artwork.

Mandala a circular design used as a symbol to express a person's striving for unity and harmony.

Meditation the act of spending time in quiet thought and contemplation.

Metamorphosis the process of transformation from an immature to an adult form.

Monochrome the use of only one color or hue.

Motif a strong and possibly recurring shape or image in a design.

Primary colors the three colors (red, yellow, and blue) from which all other colors can be mixed.

Protractor a transparent, semicircular plastic tool designed to measure the size of angles.

Radius a straight line from the center point of a circle to its outside edge.

Secondary colors the colors that are made by mixing the three primary colors.

Shading the lines an artist uses to represent gradations of tone.

Stencil a sheet of paper or card with a cutout design so that when paint is applied to it, the design will transfer to the surface beneath.

Symbol an image used to represent something abstract.

Symbolism the depiction of something using symbols or giving symbolic meaning to objects.

Symmetrical balanced, with each half (of a design) reflecting the other.

Template a pattern used for making many copies of a shape.

Tertiary colors the colors formed by mixing a primary and a secondary color.

Thumbnail sketch a small sketch, quickly executed.

Tonal value the lightness or darkness of a color.

Index